Perspective
and other drawing systems

Fred Dubery and John Willats

 Van Nostrand Reinhold Company

New York Cincinnati Toronto London Melbourne

Copyright © 1972, 1983 by Fred Dubery and John Willats
Library of Congress Catalog Card Number 82-50971

ISBN 0-442-21960-1 (cloth)
ISBN 0-442-21959-8 (paper)

Printed and bound in Spain by Grijelmo S.A., Bilbao
Designed by Judith Allan

Published by Van Nostrand Reinhold Company Inc.
135 West 50th Street, New York, NY 10020

Van Nostrand Reinhold Publishers
1410 Birchmount Road
Scarborough, Ontario M1P 2E7, Canada

16 15 14 13 12 11 10 9 8 7 6 5 4 3 2 1

First edition published 1972 by Van Nostrand
Reinhold under the title Drawing Systems

Contents

Introduction

Engineers, architects, industrial designers, graphic designers, painters and sculptors – that is, artists and designers whose language is wholly or partly visual – are inclined to use the drawing systems traditional in their own fields without considering how useful a particular system may be in solving a particular problem. Our aim in writing this book has been to present and define all the common drawing systems, taking our examples from a wide range of different disciplines, in the hope that artists and designers who need to use these systems may have a greater range of choice.

Most of the book is taken up with an account of drawing systems, such as oblique projection and perspective, which are based on projective geometry, although our book begins with a brief account of schematic systems. In all these systems, spatial relationships between elements in the picture are used to represent spatial relationships between corresponding elements in the real world. In oblique projection, for example, oblique lines across the picture surface are used to represent edges in the third dimension. Shadows are, of course, produced by the projection of *light*; and in pictures containing shadows the shapes and positions of the areas of tone used to depict the shadows can in turn indicate the shapes and positions of objects in the real world. There are, however, other kinds of transformation systems which we have not described. In atmospheric perspective, for instance, objects nearer the spectator are depicted using stronger tone or colour *contrasts*, compared with objects which are further away: a way of indicating depth which is not directly dependent on projective geometry, but which depends on the filtering and diffusing properties of the atmosphere.

The simplest and most special projection systems are described first, followed by systems which are more general and more complex[1]. It seems that this is the order in which various systems develop historically, within a particular culture[2], and also the order in which these various systems are acquired by children[3]. However, although many of our examples are drawn from the past, our purpose is formal rather than historical or psychological; we have tried to describe the various systems as precisely as possible, together with some examples of how they have been used in practice.

Artists and designers have a great wealth of graphic elements from which to choose: points, lines, areas, tones and colours. The real world, too, is also made up of a great variety of elements, or 'scene primitives' as they are sometimes called[4]: corners, edges, faces, and, again, tones and colours. Thus since pictures (like sentences) cannot literally contain the objects they represent, what we see in a picture as chairs or people are really only patches of ink or blobs of paint: picture primitives which stand for, refer to, or *denote* corresponding scene primitives.

As Kennedy (1974) has pointed out, lines alone can stand for an enormous variety of elements in the real world: edges, cracks, smooth contours (like the sides of cheeks or apples), thin wire-like forms (like threads or hairs), the boundaries between areas of different tones or colours, and so on. As human beings, we can usually recognize

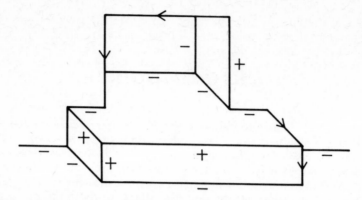

1. (above) A line drawing, showing bounding contours labelled with an arrow, convex edges labelled with a '+' sign, and concave edges labelled with a '−' sign.
(below) A drawing of an impossible object. The question mark labels a line which cannot be definitely identified either as a concave edge or as a bounding contour. (Adapted from Huffman, 1971, figs 2 and 4.)

immediately what the marks in a picture stand for; but the very ease with which we can do this prevents us from realising what an astonishing feat it is. In order to try to discover how we do it, workers in the field of artificial intelligence have tried to write computer programs which can interpret line drawings 'automatically'; that is, without appealing to human intuitions. In the course of this, they have developed labelling systems for line drawings in which arrows stand for bounding contours, + signs for convex edges, and − signs for concave edges. It has been found that drawings which cannot be labelled consistently, or which can be labelled in several different ways, appear to human beings as impossible or ambiguous (fig. 1). A number of artists, particularly Picasso and Paul Klee[5], have played with the potential ambiguity

of reference of the lines in line drawings; either for expressive reasons or, like the computer programmers, to explore the rules of the game. It seems that these rules have to be learnt, at least in the *production* of drawings: young children begin by using closed lines to stand for the whole surface of an object, and then go on to use regions (areas) to stand for separate faces. It is not until much later that they go on to use lines to denote individual edges[6].

Transformation systems alone, therefore, are insufficient to describe pictures. Representation depends upon both transformation and denotation; and the transformation systems which we describe in this book are only half the story.

This book is divided into three main sections. In the first section we describe the parallel projection systems, such as orthographic projection and the oblique projections. In these systems, the projection rays are parallel and result in drawings in which the orthogonals (lines representing edges in the third dimension) either disappear (as in orthographic projection), or form parallel lines across the picture surface. Drawings in all the projection systems, including the parallel systems, imply a certain point or direction of view from which the object is seen; nevertheless, in the parallel systems the features of objects are described relative to a frame of reference based on the principal axes of the object itself, rather than being described as they appear from a particular point of view. For example, in these systems, edges are often drawn as true lengths; and edges which are parallel in the scene are represented by parallel lines in the picture.

The second section describes pictures in perspective. Here, the emphasis is on objects or scenes as they are seen *from a particular point of view*. To use Marr's terminology (Marr, 1978) we can say that pictures in perspective are based primarily on transformations from *viewer-centred* descriptions; while pictures in the parallel systems are based primarily on transformations from *object-centred* descriptions. The third section describes pictures made up of mixtures of systems.

Notes are provided at the end of each chapter, and references, which use the author and date method of citation in the chapters, are given in full at the end of the book.

Categorizing pictures in this way raises certain questions. Why did artists in different periods use different systems? Are the systems just different, like different languages, or do they represent different stages in some evolutionary process? How do people learn to use these different systems? Is using a particular system something that happens at an unconscious level; or were artists such as Bonnard (fig. 29) or Gris (fig. 113) conscious of what they were doing? What methods did artists such as Brunelleschi (figs 62-8) or Vermeer (fig. 78) actually use when they produced their paintings? Although we raise these questions, it is not possible here to answer them adequately; either because sufficient evidence is not yet available, or because the necessary research has not yet been carried out. Before such questions can be answered, moreover, it is necessary to begin by defining the various drawing systems as precisely as possible, so that they can be recognized and named. This is what we have tried to do.

1. Schematic systems

'Schematic' is a term which is used rather loosely to describe pictures which are either very simplified, or which do not appear to be based on one of the normal projection systems. In these pictures it is often topological relationships, rather than projective relationships, which are important. In the London Underground map, for example, the only property of the real scene which is represented is the way in which stations are *connected*. Connections are represented by line junctions; and the shapes of the lines connecting these junctions are relatively unimportant.

Successful drawings of this kind appear very simple and obvious, but it was a long time before London Transport Publicity Department could be persuaded to accept Henry C. Beck's suggestion for a 'topological' map of the London Underground. In

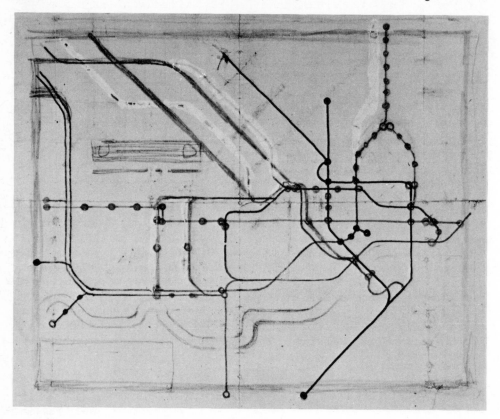

2. Henry C. Beck's original sketch for a 'topological' map of the London Underground, made in 1931 on a sheet of paper torn from an exercise book.

early maps of the Underground the shapes of the lines reflect the shapes of the real railway. Fig. 2 shows Beck's original sketch for a 'topological' drawing in which this relationship is more or less abandoned; this sketch was the forerunner of the present day Underground and Subway maps which we now take for granted.[1]

The key idea behind the drawings of this kind is the elimination of unwanted information. The first drawings of electrical apparatus were pictorial, designed to please the eye and show the physical appearance of the various pieces of apparatus. Gradually these drawings became more abstract, until finally the lines showed only the electrical circuit and pictures of the apparatus were replaced by conventional symbols. The logic circuit of a computer (fig. 3) is, in a way, both a drawing of the logic and the electrical circuit by which the logic is affected.

3. Logic circuit from a computer (micrologic chip), *c.* 1967. 0.03 × 0.03in. [0.08 × 0.08cm.]

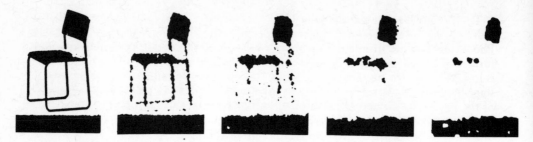

4. Photographs of a chair, taken from distances up to 300m. As the distance increases, and the image on the film gets smaller, so less detail can be picked up, depending on the grain size of the film.

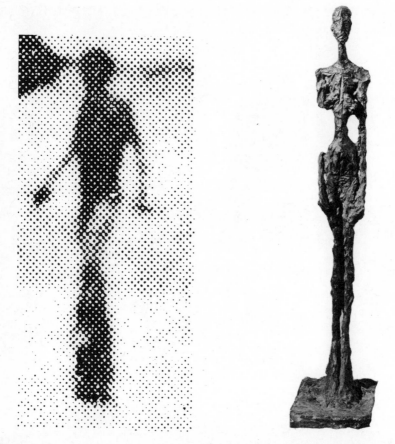

5. (left) A newspaper photograph of a hijacker. The method of reproduction (Benday dots) reduces the amount of information available still further.

6. (right) Alberto Giacometti: *Standing Woman*, 1958-9. Bronze, ht. 27.7in. [69.2cm.]. Tate Gallery, London.

There are two main ways in which the amount of information in a picture may be reduced. Fig. 4 shows photographs of a chair taken from various distances up to 300m. Photographs taken from close up show a fair amount of detail; in those taken from further away the amount of detail is progressively reduced, until so much information is lost that the chair becomes unrecognizable. The amount of information lost at each stage depends on the size of the marks used in the picture: in this case, the grain size of the film in the negative. These pictures may be compared with a photograph of a hijacker – taken from a considerable distance away – (fig. 5) and with a photograph of a piece of sculpture by Alberto Giacometti (fig. 6).

Reduction of information by optical or mechanical devices takes as a rule no account of the *meaning* of the picture. In a map, on the other hand, the most important features might be bays or harbours, and these features must be retained, irrespective of their physical size. In the map shown in fig. 7, it is features of this kind which are retained; very little attention has been paid to actual physical shapes and sizes.

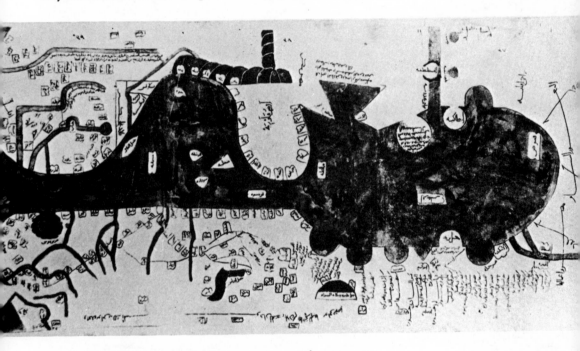

7. Ibn Hankal: *A map of the Mediterranean, c.* 11th century AD.

2. Parallel projection systems

All the projections systems may be defined in terms of either primary or secondary geometry[1]. In terms of primary geometry, projection lines or rays from points in the scene pass through three-dimensional space and intersect the picture plane to form the picture. The different systems are defined according to whether these projection rays diverge, converge or run parallel, and the angles at which these rays intersect the picture surface. Definitions in terms of primary geometry are very general, and are not necessarily related to the kinds of objects represented, or to their orientation.

Definitions in terms of *secondary* geometry relate directions on the picture surface to directions in the scene. Orthographic projection, for example, may be defined by saying that vertical directions across the picture surface stand for vertical directions in the scene, and horizontal directions across the picture surface stand for horizontal directions in the scene which run parallel to the picture plane. (In cases where objects are shown with their front faces parallel to the picture plane, we can say that horizontal directions across the picture surface stand for horizontal directions across the front face of the object.) Directions in the third dimension (that is, from front to back of the object or scene) are simply ignored. Definitions in terms of secondary geometry are really only useful for rectangular objects, and in many of the systems are based on the assumption that the object is shown with one of its faces parallel to the picture plane.

A picture may be *recognized* as being in one system or another according to the directions of the orthogonals across the picture surface. (Orthogonals are the lines in the picture representing edges in the scene which are at right angles to the picture plane). In single point perspective, for example, the orthogonals converge to a single vanishing point, usually somewhere towards the middle of the picture. In the parallel systems, such as oblique projection, the orthogonals are parallel. In orthographic projection there are no orthogonals as such, because the projections of edges normal to the picture plane appear as points.

Orthographic projection or orthogonal projection

In terms of primary geometry, orthographic projection (or orthogonal projection, as the system is also called) is the least general system, since the projection rays are parallel and intersect the picture plane at right angles in both directions (fig. 8). Where the light source is at a great distance, silhouettes approximate to orthographic projections; and the setting sun, directly facing a flat wall, will throw shadows on to it which approximate to orthographic projections, since these shadows are the same shapes and sizes as the objects they represent.

In terms of secondary geometry, drawings in orthographic projection may be thought of as showing one face or *aspect* of an object, as if the object had been 'rolled up' with printing ink and then pressed down on to the paper. Orthographic projections thus show faces as true shapes; but obviously this definition can be applied only to rectangular objects which have flat faces.

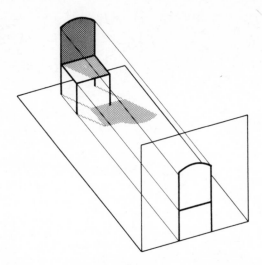

8. The primary geometry of orthographic projection. The projection rays intersect the picture plane at right angles in both the horizontal and vertical directions.

An illustration of the way in which true orthographic projections developed historically from more primitive systems can be seen in the development of Greek vase drawings. The very earliest drawings (those of the geometric period) are little more than stick figures with the limbs and body slightly thickened. All the axes of the component parts of these figures are set in the plane of the picture, irrespective of their orientation in real space; and there is no representation of occlusion or 'overlap'. Gradually the shapes of these drawings became more refined until they came to resemble true silhouettes; and the representation of overlap also began to be introduced. Then the principal axes of the forms began to be shown in foreshortened positions in relation to the picture plane. This finally resulted in true orthographic projections of the scene as a whole, such as the brilliant *Leavetaking* by the artist known as the 'Achilles painter' (fig. 9). Because drawings of this kind are so 'realistic' and because we are used to seeing orthographic projections used by architects and engineers for buildings and machinery, we are inclined to think of drawings like the *Leavetaking* as being in perspective; but this is not the case.

It is well worth trying to draw a life figure (or some other complex object) in orthographic projection. Using a scale rule, true vertical measurements in the scene are used as true vertical measurements in the picture, and true horizontal measurements in the scene (taken parallel to the picture plane) are used as true horizontal measurements in the picture. Measurements in the third dimension are not represented, except through the use of overlap. How did the Greeks do it? Did they take measurements from the figure, perhaps relating these measurements to some canon of proportion? Or did they use an optical method, based on silhouettes?

Objects and scenes may be shown in orthographic projection without reference to a viewer at any particular *point*, although pictures in true orthographic projection do imply a certain *direction* of view. Because orthographic projections show the true dimensions and shapes of faces of objects, irrespective of any particular point of view,

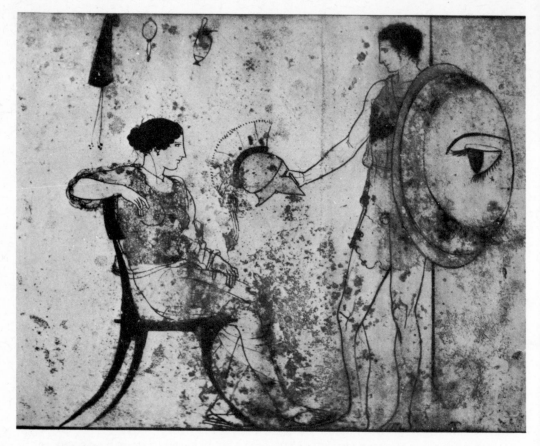

9. 'Achilles painter': *Leavetaking*, mid 5th century BC. From a tomb *Lekythos*, National Museum, Athens.

they are widely used for architectural and engineering drawings in the form of plans, sections and elevations. The major drawback of the system (the fact that dimensions in the third dimension cannot be shown) is overcome by showing at least three related views (fig. 10). Three related views are usually sufficient to define any object completely; and from these views other auxiliary views can be obtained by projection across the picture surface: either showing the object from some other direction of view, or even, if necessary, showing it in perspective or some other system.

From drawings by Uccello and Dürer it is clear that this principle was understood during the early Renaissance. Implicitly, it underlies Alberti's *costruzione legittima*, and a system of related plans and elevations must have been in use for architectural drawings at least after the time of Brunelleschi. The discovery of this principle was in many ways just as important as the discovery of scientific perspective.

However, it was not until the beginning of the eighteenth century that the full potential of the system was realized by Gaspard Monge, a French military engineer responsible for designing fortifications. His method of projective geometry, although

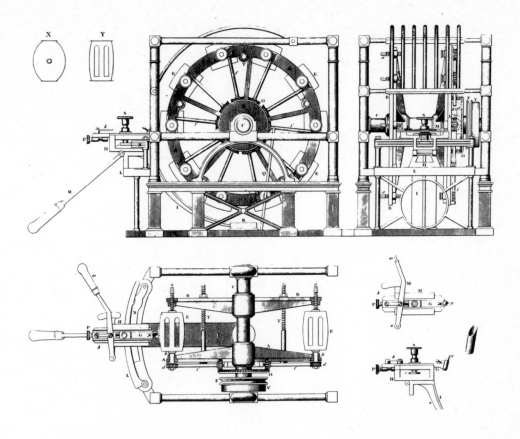

10. J. Farey: *Block Machinery at Portsmouth*, 1820. Engraving from Ree's *Cyclopedia*.

at first on the French secret list, soon became the common language of engineering and architectural drawing in Europe; and he also standardized the relationship of plan, side and front views in the form now known as 'first angle projection' (fig. 11). In this method the object is imagined as being placed inside a box with three or more sides. Faces of the object are projected back on to the sides of the box, which are then unfolded. This was a very necessary step, as the increasingly complex machines which developed with the industrial revolution, of which Brunel's block-making machinery (fig. 10) is typical, could not be described by the old oblique projections, or casually related orthographic views, without the drawings becoming hopelessly confused.

In America, a similar method called 'third angle projection' was adopted (fig. 12) but in this case the various views are projected forward and the box is imagined to be transparent, so that the images appear on the outside. The relationship of object, image and picture plane in this case is similar to that used in perspective drawings.

Thus in the European system, the emphasis is on the various faces of the object, pressed down on the paper; whereas in the American system, the emphasis is on the

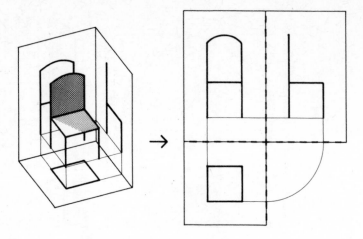

11. Orthographic projection: first angle projection.

12. Orthographic projection: third angle projection.

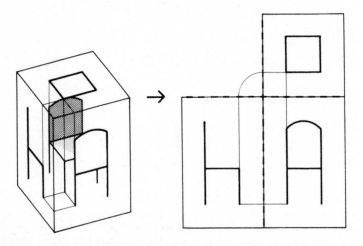

various views which a viewer would get by walking round the object – a psychologically different approach, although the basic principle of projection by parallel rays is the same in each case.

Transformations may be carried out algebraically rather than geometrically. The position of each point on the surface of the object is first defined in terms of Cartesian coordinates, and these coordinates are then transferred using transformation equations. This method, previously of only theoretical interest, is now of great importance, since these transformations can be carried out very rapidly by computer and the views drawn out by graph plotter or displayed on a cathode ray tube. The drawings of the Greek head shown in fig. 15 were obtained by using a graph plotter.

Finally, algebraic transformations can be interpreted in two ways: what Klein (1939)

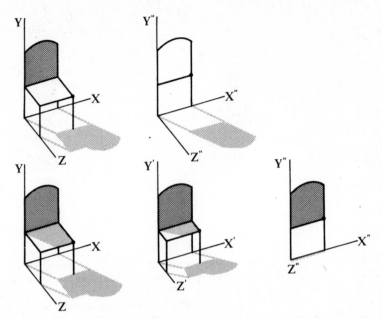

13. (top) Algebraic transformations: Klein's 'passive' method. The transformation equations for orthographic projection are:

$$x'' = x$$
$$y'' = y$$
$$z'' = o$$

14. (above) Algebraic transformations: Klein's 'active' method. The values of x, y and z remain the same, but the spatial system *as a whole* is compressed until the object lies within two-dimensional space.

calls the 'active' and 'passive' interpretations. In the 'passive' interpretation (the most usual approach) the *values* of the coordinates are changed by the transformation equations. Fig. 13 shows a simple example of a 'passive' transformation resulting in an orthographic projection. In the 'active' approach the values of the coordinates remain the same, but the spatial system *as a whole* is distorted in some regular way until it lies within a two dimensional surface. Figs 14 and 15 show examples in which the spatial system has been compressed along the direction of one of its principal axes in order to produce drawings in orthographic projection. Pictures in any of the drawing systems based on projective geometry, including perspective, may be obtained by deforming objects or scenes in some appropriate way. At an intermediate stage, these objects or scenes will look like pieces of relief sculpture. Some of the early tin toys approximate to relief sculptures in orthographic projection (*cf.* fig. 16), while the stage scenery of Palladio's *Teatro Olimpico* (see Chapter 8: *anamorphic stage design*) is a large scale example of relief sculpture in perspective.

From this point of view, pictures may be regarded as special cases of relief sculpture, compressed until they lie wholly within two-dimensional space.

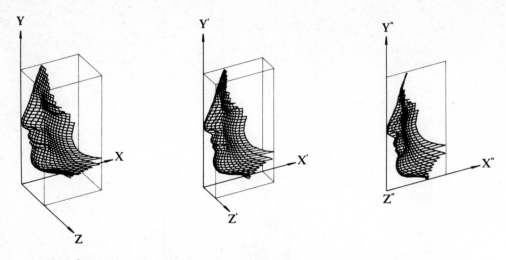

15. A drawing by computer, based on a 6th century BC Greek stone carving. A surveyor's digitizer was used to establish the positions, in Cartesian coordinates, of about 800 points on the surface of the carving. These points were transformed into trimetric projection, using a computer, and the drawing was obtained by joining up the points using a graph plotter. Our thanks are due to the Land Surveying Department and the Computer Graphics Section of the North East London Polytechnic.

16. John Willats: *Zephyrun and Flora* (after Antonia Corrandini, *c.* 1725), detail, 1977. Steel, aluminium and cellulose, ht. 88in. [224cm.]. Collection of the artist.

Horizontal oblique projection

Children begin to make drawings in orthographic projection at about the age of 6 or 7[2]. In the next stage of development they try to show more of the object by tacking on other faces round the edge. The difficulty with this is that it is usually impossible to get the other faces to join up satisfactorily. One way of dealing with this problem is to stop short, so that only one extra face is added; this will result in drawings in either horizontal or vertical oblique projection.

Drawings in horizontal oblique projection appear in Egyptian wall paintings (fig. 17), and then again in Greek vase drawings after about the middle of the fifth century BC. The method is simple enough with rectilinear objects such as tables and chairs, but uncomfortable compromises sometimes appear when it is applied to more complex objects like four-horse chariots.

17. *Painting of a banquet* (detail), from Thebes, Egyptian, New Kingdom. British Museum. London.

It would seem inappropriate to dignify such a rough and ready approach into a system, but in fact horizontal oblique projection can be applied quite strictly. Using our previous illustration, if the rays of the the setting sun strike a wall obliquely, rather than at right angles, then the shadow of an object lying parallel to the wall will be elongated into a horizontal oblique projection. Alternatively, rays from the object may be projected forward so that they intersect the picture plane at an oblique angle (fig. 18). Fig. 19 shows a plan and elevation of the primary geometry of horizontal oblique projection: pictures in any of the projection systems may be obtained by drawing plans and elevations of the primary geometry, and this one way of obtaining pictures in perspective (see Chapter 5; and fig. 64).

One common use for drawings in horizontal oblique projection as applied to more complex objects is for portrait heads, where the side and front views are of most importance, and the top view of little consequence. A drawing by Villard de

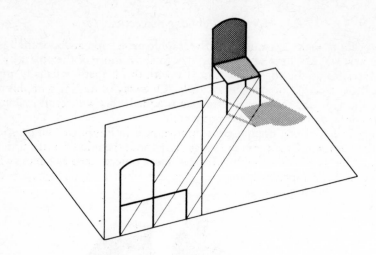

18. Horizontal oblique projection. The projection rays intersect the picture plane at an oblique angle in the horizontal direction only.

19. Using a drawing board, the drawing in horizontal oblique projection has been obtained by projection from the plan and elevation of the chair. Engineers would call this an 'auxiliary view'; but note that for horizontal oblique projection the projection rays are at an oblique angle to the picture plane.

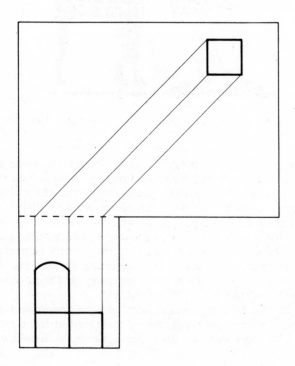

20. (left) Villard de Honnecourt: *Drawing of a man's head from a sketchbook, c.* 1230. Bibliothèque Nationale, Paris. 21. (centre) Pablo Picasso: *Deux femmes sur la plage* (detail), 1947. © S.P.A.D.E.M. Paris, 1982. 22. (right) Head in horizontal oblique projection, by computer.

Honnecourt (fig. 20) shows how the head has been extended in an attempt to show both these views at once. A similar elongation appears in many of Cranach's portraits. Perhaps the best known examples are found in some of Picasso's portraits (fig. 21). We may compare these examples with a drawing of a head in strict horizontal oblique projection obtained by using a computer (fig. 22).

Examples of objects drawn in horizontal oblique projection may sometimes be found as an alternative to oblique projections in Chinese landscape paintings (fig. 23).

23. Huang Kung-wang (1269-1354): *Mountain Village.* Ink on paper. Formerly Yamamoto Collection, Tokyo.

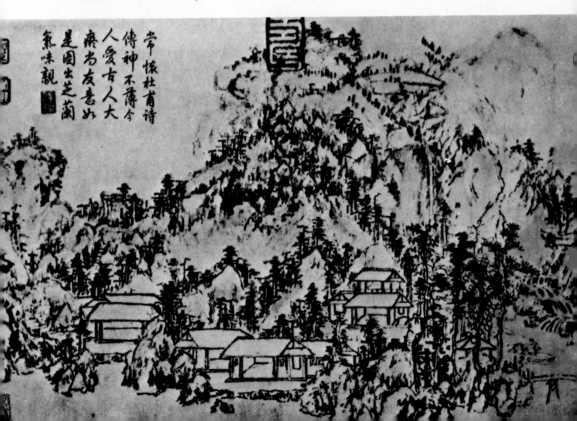

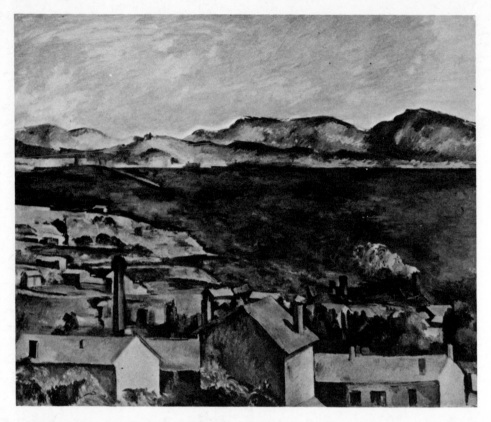

24. Paul Cézanne: *The Bay of Marseilles seen from L'Estaque*, c. 1885. Oil on canvas, 30.4 × 38.9in. [75.9 × 97.2cm.]. Collection of The Art Institute of Chicago.

Cézanne used a very similar approach in many of his landscape paintings (fig. 24). In his still life paintings, too, he often made use of approximations to horizontal and vertical oblique projections, sometimes combining both systems within a single painting. By using approximations to the parallel systems, Cézanne was attempting to show the 'more complete object in our mind' rather than the object as it appeared from a particular point of view[3]. This is a theme to which we shall return in discussing the origins of Cubism in Chapter 10.

Vertical oblique projection

A simple form of vertical oblique projection may be obtained by adding together the front and top views of an object (fig. 25), or, in the case of an interior, by adding a plan of the floor to a view of one wall. The system is also common in Indian and Persian miniature paintings (fig. 26).

A strict version of vertical oblique projection is obtained by projecting the object or scene on to a picture plane using projection rays which are oblique to the picture plane in the vertical direction, but at right angles to it in the horizontal direction (fig.

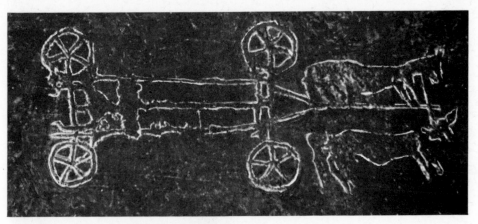

25. Iron age drawing of chariot and horses.

26. Mughal, c.1565: 'Hamza's son, Rustam, with his mistress, Mihr Asruz, in a garden pavilion; attendants plying them with refreshments', from the *Hamzanama*. Painting, 27.25 × 22.5in. [69 × 57cm.]. Victoria & Albert Museum, London.

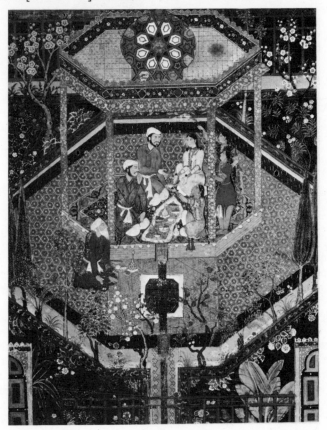

27. (left) Vertical oblique projection. The projection rays intersect the picture plane at an oblique angle in the vertical direction.

28. (right) A photograph approximating to a vertical oblique projection.

29. (opposite) P. Bonnard: *Nude in a Bathtub*, 1935. Oil on canvas, 41.2 × 25.6in. [103 × 64cm.]. © S.P.A.D.E.M. Paris, 1982.

27). This is equivalent to viewing the scene at an oblique angle from a considerable distance, or photographing it at an oblique angle with a telephoto lens (fig. 28). Shadows thrown by the sun onto a horizontal surface may also take the form of vertical oblique projections.

In his early paintings and drawings, Bonnard used a conventional version of perspective, but after about 1920 he experimented with all kinds of drawing systems, including vertical oblique projection (fig. 29). Paradoxically (since the system is associated with a long spectator distance) the effect here is to involve the spectator more intimately in the scene. Vertical oblique projection also formed the basis for many Cubist still life paintings. Fig. 30 takes a detail from Juan Gris' *Breakfast* (fig. 113) and shows how it may be obtained by projection from a perfectly ordinary cup. The system is particularly suitable for pictures of cylindrical objects such as cups or

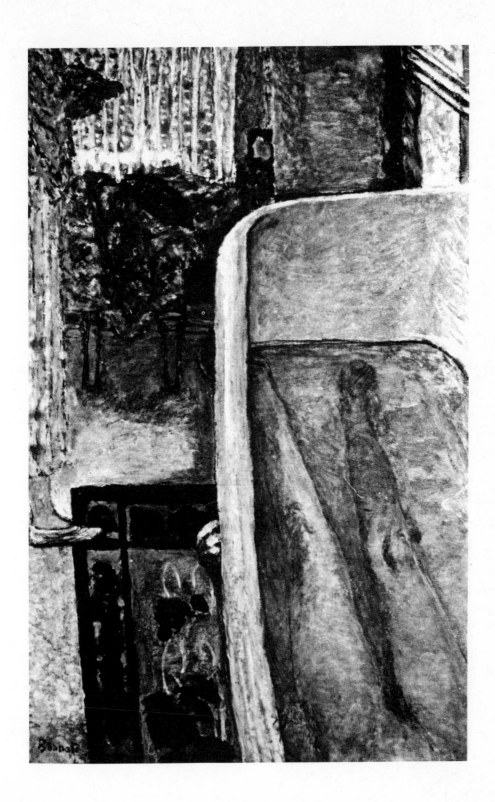

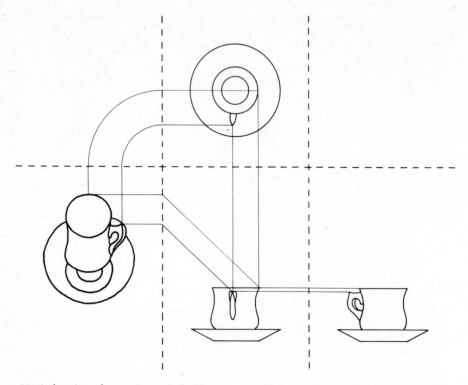

30. A drawing of a cup in vertical oblique projection. Compare with the drawing of the same cup in oblique projection (fig. 34), and the pictures of cups in Juan Gris' *Breakfast* (fig. 113).

bowls, whereas the use of perspective or oblique projection can produce distortions which are often unacceptable (fig. 34).

Because one direction across the picture surface (the vertical direction) is used in this system to stand for two different directions in the scene (vertical directions, and horizontal directions away from the picture plane) drawings in this system tend to be rather ambiguous. For this reason the system is not used for engineering drawings; but occasional rather esoteric examples of its use may be found in recent architectural drawings.

Axonometric or planometric projection

In axonometric projection a plan view of the object is first drawn at an oblique angle to the picture surface (usually but not always 45°), and side and front views are then added with the verticals shown as true lengths. In terms of primary geometry, the object is first turned about a vertical axis, and then projected using vertical oblique projection (fig. 31).

This system seems particularly suitable for architectural drawings, partly because the plan is shown as a true shape, and partly because drawings in this system can give a good idea of the shapes of the spaces in a building, rather than showing isolated plans

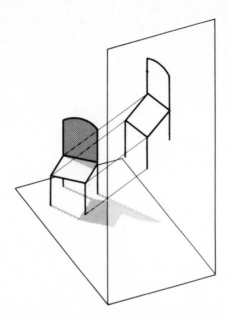

31. Axonometric projection. The object is turned about a vertical axis, and the projection rays intersect the picture plane at an oblique angle in the vertical direction.

or elevations. Axonometric projection for architectural drawings was first introduced by Auguste Choisy at the end of the nineteenth century. It was used by Malevich and the Russian Constructivists, and in the 1920s it was taken up by Le Corbusier, and by Theo van Doesberg and other members of the De Stijl group. The system has recently become very popular among architects. Fig. 80 shows the scene depicted in Vermeer's *The Music Lesson* (fig. 78) drawn in axonometric projection.

Oblique projection

In ordinary oblique projection the side and top views of the object are tacked on round the edges of the front face. In order to make the side and top faces join up, they have to be distorted; and this means that the line representing the edge which is common to both faces must run at an oblique angle across the picture surface. In strict oblique projection, the lines representing the other two side edges should be parallel to this first oblique line (figs 32a and 32b). In practice, the oblique edges sometimes diverge, giving an effect of inverted perspective (fig. 32c). Alternatively, the oblique edges may converge, giving an effect of normal perspective (fig. 32d). The oblique edges may be represented by lines of any length: in 'cavalier oblique' projection (fig. 32a) the lines are drawn as true lengths, whereas in 'cabinet oblique' projection (fig. 32b) the lines are drawn as half the true lengths of the edges they represent. The angle which these oblique lines make with the horizontal is usually about 45°, but it can take any value; horizontal and vertical oblique projections are simply the special cases of oblique projection in which this angle is either zero or 90°.

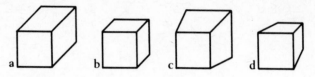

32. Varieties of oblique projection: (a) cavalier oblique, (b) cabinet oblique, (c) orthogonals diverging, (d) orthogonals converging.

33. Oblique projection. The projection rays intersect the picture plane at an oblique angle in both the horizontal and vertical directions.

In terms of primary geometry, the projection rays lie at an oblique angle to the picture plane in both the horizontal and vertical directions (fig. 33) and the lengths and directions of the orthogonals across the picture surface are determined by the angles which these rays make with the picture plane. Drawings of cylindrical objects, using this system, tend to appear distorted (fig. 34).

Any shadow which the sun throws onto a flat plane will be an oblique projection; by using shadows in architectural drawings (sciagraphy) oblique projections may be superimposed on orthographic projections, making the drawings look much more solid (fig. 35). A fuller account of these and other shadow projections is given in Chapter 9.

The ease with which drawings in oblique projection may be produced, compared with drawings in perspective, has a powerful appeal. Drawings in oblique projection show the object from a more general direction of view than drawings in orthographic, horizontal or vertical oblique projection; false attachments are avoided; and the spatial relationships within the object may more easily be seen within the drawing, so that

34. A drawing of a cup in oblique projection. Drawings or photographs of cylindrical objects in oblique projection tend to make the object look distorted.

35. A detail from an architectural drawing, showing a shadow in the form of an oblique projection.

the object looks more solid and may more easily be recognized. There is, however, something of a paradox about drawings in oblique projection; and this tends to give drawings in this system a slightly strange quality, especially when the system is strictly applied. In drawings or paintings in which oblique projections are combined this strange, slightly unreal quality seems to be enhanced; partly perhaps because of the associations with the unworldly paintings of the early Renaissance, but partly also because the comparison with perspective seems to emphasize the paradoxical nature of drawings in this system.

The paradox is as follows. In drawings in oblique projection, the front faces of objects are normally shown as true shapes, but the top and side faces are also shown in the drawing. In real life, the viewer can only see the front face of an object as a true shape if it is viewed directly from in front; but if the viewer wishes to see the top and side faces of an object, the object must be turned into a foreshortened position, when the front face ceases to be seen as a true shape. Thus there is an inherent contradiction in drawings in oblique projection: objects are shown parallel to the picture plane, and to the implied scene, but in a foreshortened position in relation to the viewer. In drawings in isometric projection (and in dimetric and trimetric projection), there is no such conflict, since objects are shown in a foreshortened position relative to both the scene and the viewer. The penalty for this is that all the faces must be shown as distorted shapes.

Drawings in oblique projection seem to have first appeared in Greek vase paintings during the fourth century BC. At any rate, there are, during that century, plenty of examples of drawings of rectilinear objects such as altars, chairs or buildings, in which the horizontal orthogonals are beginning to move upwards or downwards, so that a top, or underneath view of the object can be added to the existing front and side views (fig. 36). The subsequent development of Greek drawing from this period up to the first century BC is largely a matter of conjecture. Certainly during the Roman period the use of oblique projection for wall paintings was commonplace and it seems natural to suppose that during the period from the fourth to the first century BC artists gained more confidence in their use of the system.

Whether or not Roman painters made use of perspective in a true sense depends rather on how 'perspective' is defined, but it seems unlikely that the Roman painters

36. Drawing of a temple, from an Apulian vase, 4th century BC.

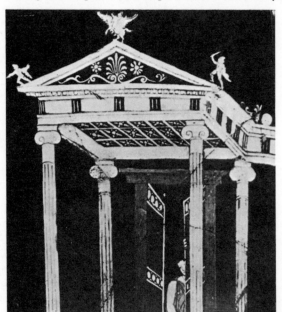

37. Okumura Masanobu (1686-1764): *A Man and a Courtesan watching a Young Man Write*. Woodcut, 9.7 × 14.5in. [24.3 × 36.2cm.]. Metropolitan Museum of Art, New York.

thought of perspective in terms of primary geometry. In terms of secondary geometry, there are many examples of paintings in which the orthogonals converge, and a few cases in which there is a definite vanishing point; but there are also many paintings in which the orthogonals are parallel or even diverge. It may be supposed that in this period, as during the Renaissance, and even up until the nineteenth century, more sophisticated artists tended to use perspective, while the naïve or jobbing painters were content with oblique projection. It is, however, conceivable that, after empirical perspective had been more or less mastered, there was a deliberate return during the Third and Fourth style periods to a strict version of oblique projection, for the sake of flattening the painting and emphasizing the wall surface. If this were true, a parallel could be drawn between the change from late-Roman to Byzantine painting, and the change from late nineteenth-century painting to Cubism.

Oblique projection seems to have arrived in China from Rome by way of India round about the first or second century AD. During the journey the perspective element, perhaps never very firmly established, was lost. Throughout its whole history up until the eighteenth century Chinese painting is remarkable for the consistent way in which oblique projection was used, at any rate so far as rectilinear objects were concerned. The orthogonals are nearly always parallel, and the angle between the orthogonals and the horizontal is usually close to 45°.

One advantage of oblique projection is that pictures in this system can be extended

indefinitely in any direction, in contrast with pictures in perspective which become hopelessly distorted when the angle of view becomes too large (Chapter 7, figs 86 and 87). A corresponding disadvantage is that since there is no diminution of size with distance in strict oblique projection, as there is in perspective, large objects such as trees or mountains tend to swamp the picture. In Chinese landscape painting this difficulty is overcome by restricting the use of oblique projection to isolated objects such as houses, and setting them on the surface in such a way that the spaces between them remain ambiguous. Similarly, in Japanese woodcuts, the objects in the foreground may be drawn in oblique or isometric projection, and the background is put in in miniature, like the early Italian paintings. In the woodcut *A Man and a Courtesan Watching a Young Man Write* (fig. 37) the landscape appears in miniature in the form of a painting.

There are a number of advantages in using oblique projection for rectangular objects, but for complex objects such as the human figure the system is less suitable. Portrait heads or life figures are very difficult to draw in oblique projection, and tend to look distorted. There does, however, seem to be something of a quality of oblique projection about the figures in Japanese woodcuts: the heads of the figures in fig. 37 may be compared with a drawing of the Greek head, in strict oblique projection, produced by computer (fig. 38).

In the West, the use of perspective or near-perspective soon degenerated into a non-spatial use of oblique projection after the fall of the Roman Empire. For roughly eight hundred years, the Byzantine artists seem to have used the outward forms of oblique projection without relating the positions of objects or parts of objects to each other, or to real space; so that the orthogonals often become little more than decorative lines across the surface. Within single objects the orthogonals were often divergent; and where more than one object appeared in the picture the orthogonals very frequently ran in opposite directions (figs 39 and 40). Thus individual objects are shown as solid but the divergence of the orthogonals has the effect of flattening the picture space as a whole. How far this technique was deliberate and how far it occurred through simple ignorance or misunderstanding of the Roman tradition; how far it arose through the use of mosaics on curved vaulting or domes; or how far it related

38. Head in oblique projection, by computer.

39. *The Numbering of the People*, 1300-20. Mosaic from St Saviour in Chora (Kariye Cami), Istambul. 40. Line drawing, taken from fig. 39.

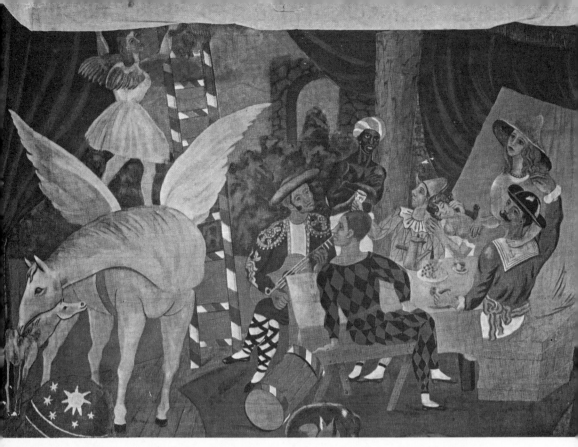

41. Pablo Picasso: *Backdrop to Parade*, 1917. © S.P.A.D.E.M. Paris, 1982.

to the other worldly beliefs of Christianity is hard to say. At any rate, the use of diverging orthogonals did not appear again until the beginning of our own century, when the technique was taken up by the Cubists, notably Picasso (fig. 41) and Gris (fig.113).

With the beginning of the Renaissance, and the rediscovery of real space in painting, artists such as Giotto began to use converging orthogonals to show the apparent convergence of parallel edges in the real world; but in many paintings of this period objects drawn in oblique projection and objects drawn in empirical perspective appear together in the same picture (fig. 57). The architects Brunelleschi and Alberti are credited with the discovery of true scientific or artificial perspective: Alberti's *Della Pittura* describing his *costruzione legittima* appeared in 1436 (Chapter 5). With less sophisticated artists, however, the casual adaption of oblique projection to a rough and ready empirical perspective persisted for centuries after the formal laws were discovered.

The first artist to use oblique projection as a deliberate alternative to perspective, rather than as a crude version of it, seems to have been Leonardo da Vinci. Leonardo was of course perfectly familiar with artificial perspective as described by Alberti, but many of the drawings in his sketchbook, particularly those of machinery and architecture, are in oblique projection. For the description of these objects, oblique projections, apart from being easier to draw, have a very definite advantage. This is well illustrated by the choice of drawing systems for the illustrations to Diderot's

Encyclopédie, published in 1758. Where the illustrations show processes taking place (such as the manufacture of pins, or cultivating the land) the scenes are in perspective, but where the objects, or the layout of the workshop, is important, then oblique projection is used (fig. 42). The advantage for the engineer or craftsman, or the socially conscious amateur for whom the book was intended, was that all lengths along the orthogonals, if not actually true lengths, were at least in constant proportion to each

42. Lucotte: *Serrures de Cofre à 1, 2, 3 et 4 fermetures*, 1771. Engraving from Diderot's *Encyclopédie*.

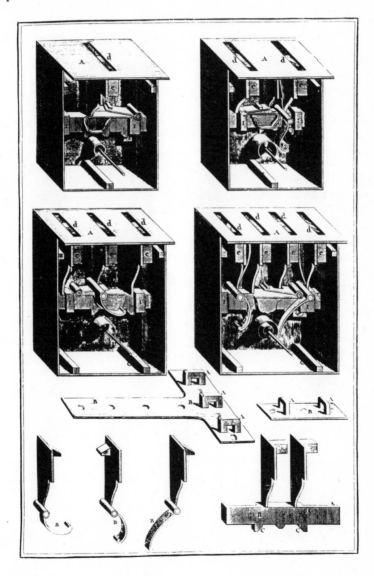

other, so that the illustrations as well as being pictorial could also be used as working drawings. This functional use of oblique projection lasted until it was replaced by Monge's system of multiple view orthographic projection. The illustrations to Ree's *Cyclopedia* (fig. 10), published in 1820, are nearly all either in perspective or in orthographic projection. By the beginning of the twentieth century, and with the invention of photography, oblique projection had almost dropped out of use, except for the naïve illustrations in toy catalogues. However, oblique projection is still taught as a system in engineering drawing, and is nowadays quite widely used for technical illustrations. More recently still, oblique projection has come back into favour for architectural drawings; to which, however, it tends to impart a certain oriental flavour.

By the end of the nineteenth century the Impressionists seemed to have brought perceptual painting to a point where no further development was possible, and the post-Impressionists began to turn towards more conceptual systems, including oblique projection. The subsequent history of painting has been largely a matter of the tension between conceptual and perceptual systems. The logical extension of nineteenth-century perceptual painting, with its emphasis on the involvement of the spectator, was out of painting altogether: first into photography and the film, and then into environmental 'happenings'. At the other extreme, the more conceptual elements of Cubism developed through Constructivism into hard-edge painting and minimal sculpture and then into conceptualist art.

The middle ground has been occupied by those painters – De Chirico (fig.112), Picasso (fig. 41) and more recently Hockney (figs 118 and 119) – who explore and illustrate this tension without necessarily seeking to resolve it. In the work of these painters, oblique projection is often used as one element in a complex mixture of systems.

Isometric projection

In an attempt to make the very complex drawings of the industrial revolution more readable, an English contemporary of Monge's, Sir William Farish, introduced a system which he called 'isometric projection'. In terms of secondary geometry, all the faces of an object are equally distorted from their true shapes so that all the faces can be joined together; the edges are shown as true lengths; and all the horizontal edges lie at an angle of 30° to the horizontal (fig. 43). Drawings approximating to isometric

43. Isometric projection: secondary geometry.

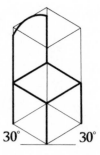

30° 30°

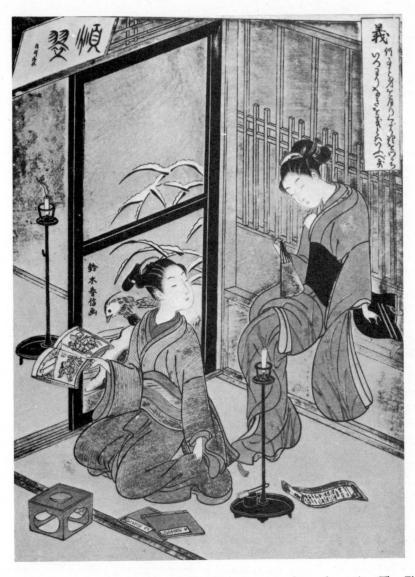

44. Suzuki Harunobu (1725-70): *Justice Righteousness*, from the series 'The Five Cardinal Virtues'. Woodcut, 11.25 × 8.5in. [28.5 × 21.5cm.]. Private collection, New York.

projection had frequently appeared in Roman, Byzantine, Persian and Chinese paintings, and in eighteenth-century Japanese woodcuts the use of isometric projections for whole scenes, as well as for isolated objects, is at least as common as the use of oblique projection (fig. 44). It is, however, unlikely that artists in any of these periods understood the system in terms of primary geometry: Sir William Farish's contribution was to show that isometric projection is a variety of orthographic

45. Isometric projection: primary geometry.

projection, with the object turned through 45° and tilted through 35.36° (fig. 45). This is equivalent to viewing a cube along the length of one of its longest diagonals; any rectangular object in this position will have its edges equally foreshortened, and all its faces equally distorted.

Isometric projection never quite achieved the popularity for which its inventor had hoped. It is not a suitable system to use for engineering working drawings because, apart from taking too long to draw, it compresses too much information into one view, the reason why oblique projection was abandoned. Isometric projection has been used for architectural drawings (fig. 46) but drawings in isometric projection cannot be developed directly from plans (axonometric projection) or elevations (oblique projection), and so, like engineering drawings in isometric projection, take too long to draw.

Isometric projection was revived during the 1930s when the Boeing Aircraft Company, faced with the problem of explaining complicated drawings of aircraft to unskilled assembly workers, started a practice of issuing isometric views alongside the normal working drawings in orthographic projection. Sometimes a straightforward isometric view was unsuitable because of difficulties involving false attachment, and variations known as 'dimetric' and 'trimetric' projections were introduced, together with various ingenious and complicated scales for drawing them. This led to the invention of draughting machines (forerunners of the XY plotter) with which these views, as well as perspective drawings, could be drawn with equal facility. Thus the simplicity of isometric projection (its main avantage as a pictorial system) became less significant. As a result, the use of isometric projection is now relatively uncommon.

46. (opposite) R.B. Brook-Greaves: *St Paul's Cathedral in Isometric Projection*, 1928. 40.6 × 30in. [101.6 × 74.9cm.].

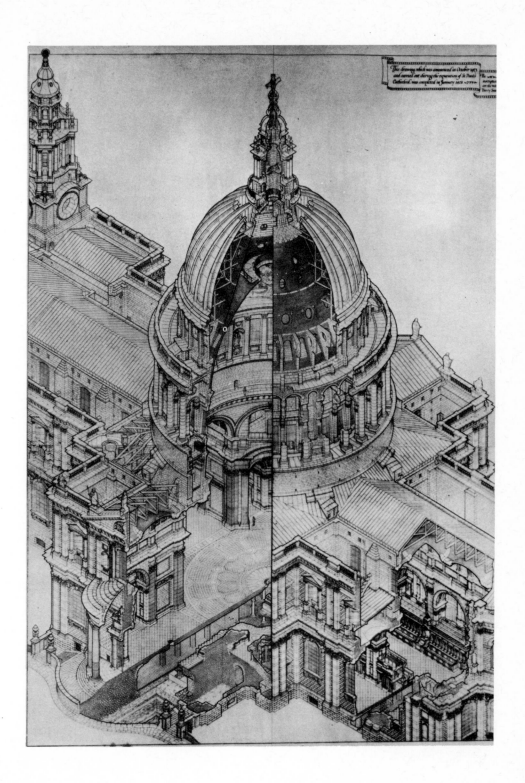

Trimetric projection

Like isometric projection, dimetric and trimetric projections are variations of orthographic projection, but in trimetric projection the object can be set at any angle to the scene. Fig. 47 shows drawings of a cube in trimetric projection, set at various angles of tilt and twist[4]. Associated with these various angles are various scales along each of the principal axes of the object to be drawn: in trimetric projection all these scales will normally be different, whereas in dimetric projection two of the scales are the same. In isometric projection, of course, all the scales are the same, and are usually taken to represent true lengths.

47. (a) details from a page showing trimetric projections of a cube at various angles of tilt and twist; (b) corresponding data for these drawings; (c) a diagram showing the arrangement of data; (d) a key to this diagram. (Taken from Coe, 1981.)

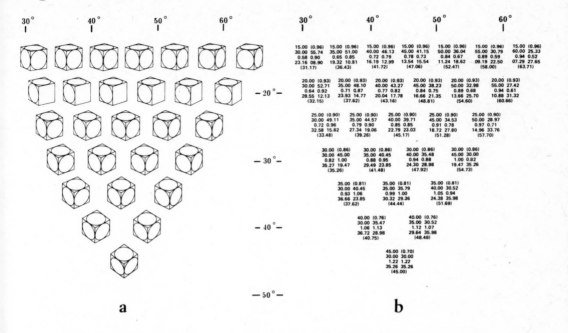

30° 40° 50° 60°

− 20° −

− 30° −

− 40° −

− 50° −

a

30° 40° 50° 60°

| 15.00 (0.96)
30.00 55.74
0.58 0.90
23.16 08.90
(31.17) | 15.00 (0.96)
35.00 51.00
0.65 0.85
19.32 10.81
(36.43) | 15.00 (0.96)
40.00 46.13
0.72 0.79
16.19 12.99
(41.72) | 15.00 (0.96)
45.00 41.15
0.78 0.73
13.54 15.54
(47.06) | 15.00 (0.96)
50.00 36.04
0.84 0.67
11.24 18.62
(52.47) | 15.00 (0.96)
55.00 30.79
0.89 0.59
09.19 22.50
(58.00) | 15.00 (0.96)
60.00 25.33
0.94 0.52
07.29 27.65
(63.71) |

| 20.00 (0.93)
30.00 52.71
0.64 0.92
28.55 12.13
(32.15) | 20.00 (0.93)
35.00 48.10
0.71 0.87
23.93 14.77
(37.62) | 20.00 (0.93)
40.00 43.27
0.77 0.82
20.04 17.78
(43.16) | 20.00 (0.93)
45.00 38.23
0.84 0.75
16.66 21.35
(48.81) | 20.00 (0.93)
50.00 32.98
0.89 0.68
13.66 25.70
(54.60) | 20.00 (0.93)
55.00 27.42
0.94 0.61
10.88 31.32
(60.66) |

−20°−

| 25.00 (0.90)
30.00 49.11
0.72 0.96
32.58 15.62
(33.48) | 25.00 (0.90)
35.00 44.57
0.79 0.90
27.34 19.06
(39.26) | 25.00 (0.90)
40.00 39.71
0.85 0.85
22.79 23.03
(45.17) | 25.00 (0.90)
45.00 34.53
0.91 0.78
18.72 27.80
(51.28) | 25.00 (0.90)
50.00 28.97
0.97 0.71
14.96 33.76
(57.70) |

| 30.00 (0.86)
30.00 45.00
0.82 1.00
35.27 19.47
(35.26) | 30.00 (0.86)
35.00 40.45
0.88 0.95
29.49 23.85
(41.48) | 30.00 (0.86)
40.00 35.48
0.94 0.88
24.30 28.98
(47.92) | 30.00 (0.86)
45.00 30.00
1.00 0.82
19.47 35.26
(54.73) |

−30°−

| 35.00 (0.81)
30.00 40.45
0.93 1.06
36.66 23.85
(37.62) | 35.00 (0.81)
35.00 35.79
0.99 1.00
30.32 29.36
(44.44) | 35.00 (0.81)
40.00 30.52
1.05 0.94
24.38 35.98
(51.69) |

| 40.00 (0.76)
30.00 35.47
1.06 1.13
36.72 28.98
(40.75) | 40.00 (0.76)
35.00 30.52
1.12 1.07
29.64 35.98
(48.48) |

−40°−

| 45.00 (0.70)
30.00 30.00
1.22 1.22
35.26 35.26
(45.00) |

b

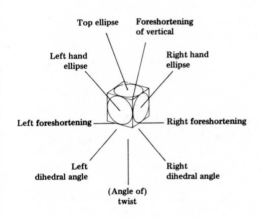

Top ellipse Foreshortening of vertical

Left hand ellipse Right hand ellipse

Left foreshortening ——— Right foreshortening

Left dihedral angle Right dihedral angle

(Angle of) twist

NB

Angles are given as decimal parts of a degree, not in minutes.

d

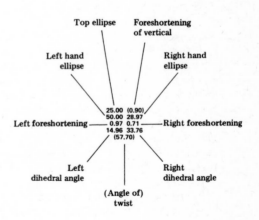

ARRANGEMENT OF DATA

For each cube the elements are arranged in the tables as follows:

Top ellipse Foreshortening of vertical

Left hand ellipse Right hand ellipse

25.00 (0.90)
50.00 28.97
Left foreshortening —— 0.97 0.71 —— Right foreshortening
14.96 33.76
(57.70)

Left dihedral angle Right dihedral angle

(Angle of) twist

c

3. Foreshortening

If a rod is held up in front of the eyes, and then slowly turned until it lies along the direction of the viewer's line of sight, its apparent length will be progressively diminished; this diminution is referred to as 'foreshortening'. The amount by which an object or part of an object is foreshortened will depend on the angle between the object and the viewer's line of sight. Where this angle is small the object will be strongly foreshortened and may be difficult to recognize. Marr (1977) has suggested that natural objects which are produced by growth, and which approximate to the so-called 'generalized cones', are most easily recognized when their principal axes are roughly at right angles to the viewer's line of sight. Similarly, pictures of such objects are most easily recognizable when the principal axes of the object are set parallel to the picture plane. It is very noticeable that in pictures of animals and human figures, in the early period of culture, the principal axes of the limbs and body are almost always shown parallel to the picture plane, irrespective of their orientations in real space. However, although this may make the individual features easier to recognize, it inevitably, as with the Egyptian wall paintings, makes the figures as a whole appear distorted. If this distortion is to be avoided, some parts of the figure must be shown in a foreshortened position. In the majority of Greek vase paintings (fig. 9) this foreshortening is reduced to a minimum: just enough to avoid an appearance of distortion, and to give an appearance of solidity, without disruption of the two-dimensial composition of the picture. In pictures in the Baroque period limbs were shown violently foreshortened, increasing the drama of the picture and disrupting the picture surface.

In contrast, rectangular objects in pictures are most easily recognized when they are shown in a foreshortened position: that is a 'general' position, so that a small change of position for the object or viewer does not change the number of faces, edges or corners which the viewer can see, and false attachments are avoided[1]. In terms of primary geometry any object, however complex, may be shown in any position by taking a sufficient number of points on its surface and finding the position of these points in the picture by projection. This is the system used in producing drawings by computer; but a drawing by Uccello (fig. 48) suggests that this method was known at least as early as the fifteenth century. A crude but effective approach to foreshortening is called 'crating'. A box or 'crate' is drawn in a foreshortened position, and the object is drawn within this foreshortened box (fig.49).

Isometric projection is a special case of orthographic projection in which the object is shown in a foreshortened position in relation to both the viewer and the picture plane. Dimetric projection (in which two of the axes of a rectangular object are equally foreshortened), and trimetric projection (in which all three axes are foreshortened to

48. (opposite) Paolo Uccello: *Perspective Study of a Chalice*, c. 1460. Ink on white paper, 11.6 × 9.8in. [29 × 24.5cm.]. Uffizi Gallery (Gabinetto dei Disegni), Florence.

49. Crating: a box or 'crate' is drawn in any desired projection system and the object is then constructed within the crate, in a foreshortened position.

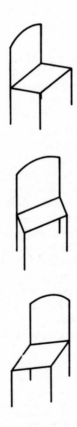

50. Foreshortening in oblique projection.

an arbitrary extent), are more general cases of orthographic projection with the object in a foreshortened position. Finally, all oblique projections give an impression of foreshortening, although the object is only foreshortened in relation to the viewer and is normally set parallel to the picture plane.

In any system, any part of an object which lies parallel to the picture plane will be projected as a true length. Parts which do not lie parallel to the picture plane will normally be foreshortened; but the degree of foreshortening depends on two separate factors: the angle between the projection lines and the picture plane (i.e. the type of drawing system used); and the angle between the part of the object concerned and the picture plane (i.e. the orientation of the object). Thus, an effect of foreshortening may be achieved in two ways: either by setting the object parallel to the picture plane but projecting it at an angle (oblique projection, and oblique perspective) or by keeping the projection rays more or less at right angles to the picture plane, but placing the object in a foreshortened position (isometric, dimetric and trimetric projections, and varieties of perspective in which the visual angle is small). When these two approaches are combined, so that objects are shown in foreshortened positions, using a system which itself produces foreshortening, some very curious effects are obtained (fig. 50)[2]. Some of the strangeness of Persian miniature paintings may perhaps be accounted for by the attempt to draw objects set obliquely, using oblique projection.

Stranger still, to Western eyes, is the artist's apparent disregard, in many of these paintings for any single direction from which the scene as a whole is to be viewed. In the Persian miniature painting *Scene from a Love Story* (fig. 51) the tower is shown from one direction, the steps at its base from another, and the projecting balcony or bay window from a third direction; and while these objects are shown as side views, the garden and its ornamental pool are seen from above. In fact, each object is drawn so that its salient or most characteristic face is set in the plane of the picture; objects are drawn in isolation, and almost no attempt is made to show the true orientations of the various objects, in relation to either the viewer or the scene[3].

In Japanese woodcuts whole scenes are often shown in a foreshortened position, using isometric projection; although the use of oblique projection is just as common. In these pictures, isolated objects are sometimes shown in foreshortened positions in relation to the scene, by using a different drawing system from that used for the picture as a whole. It is quite common to find small objects drawn in isometric projection within scenes drawn in oblique projection (fig. 37). More rarely, small objects in oblique projection are set in a scene shown in isometric projection; or small objects in oblique projection with the orthogonals running in one direction are shown within a scene in which the orthogonals run in the opposite direction[4]. Stratagems of this kind produce an appearance of foreshortening, but the individual objects are really drawn in isolation: there is no single coherent projection system used as a basis for the picture.

In the West, it is comparatively rare to find objects in pictures set in a foreshortened position, and rarer still to find whole scenes turned in relation to the picture plane. In the majority of pictures the 'grain' of the picture space is either set parallel to the picture plane or (as in Baroque painting) runs at right angles to it. Uccello's *Battle of San Romano*, for example, is full of complex objects in perspective, parts of which are inevitably foreshortened; but most of the objects as a whole are set either at right angles to the picture plane, or parallel to it. Most Renaissance paintings are based on artificial perspective, and depictions of objects towards the edges of such paintings

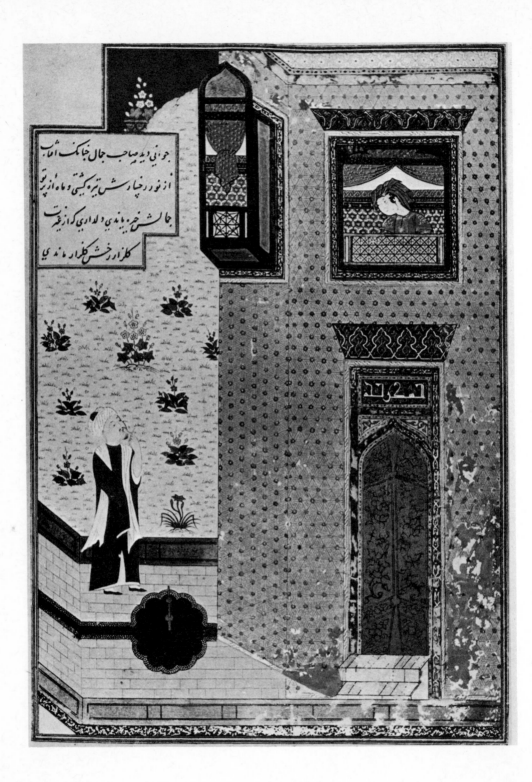

approximate to oblique projections. Objects drawn in oblique projection and shown in a foreshortened position in relation to the picture plane appear distorted (fig. 50); this is probably the main reason why foreshortening is usually avoided for rectangular objects in pictures based on artificial perspective. An apppearance of distortion may however be avoided if the objects to be foreshortened are placed at the centre of the picture rather than towards the edges: in Vermeer's carefully constructed *The Music Lesson* (fig. 78) the only two objects in the picture shown in foreshortened positions are set close to the central vanishing point.

51. Anthology of Baysunghur. *Scene from a Love Story*, 1427, copied by Shams al-Din, Herat. 7.8 × 5in. [19.7 × 12.4cm.]. Folio 26 verso, Berenson Collection, I Tatti, Settignano, Florence.

4. *Oblique projection, isometric projection, and the development of perspective*

In the tenth-century Chinese painting *Night Entertainment of Han Hsi-tsai* (fig. 52), all the objects are in strict oblique projection, but the directions of the orthogonals are so arranged that they are directed towards the central axis of the picture. To Western eyes this system looks very like linear perspective, but this impression is deceptive. There is no question of a fixed viewpoint, and no change in scale in either the figures or the objects as they recede in space. To us it seems strange that this kind of drawing did not immediately develop into artificial perspective, but although, throughout the history of Chinese and Japanese drawing, examples appear which are very close to perspective, the system was never consistently developed as it was in the West. The need to involve the spectator in the painting is peculiar to the West, and then only in two limiting periods: the Roman Empire and the Renaissance. It seems likely that painting in both these periods was preceded by an experimental stage,

52. Ku Hung-chung: *Night Entertainment of Han Hsi-tsai* (detail), 10th century AD. Colour on silk, 11.6 × 135.2in. [29 × 338cm.]. Chinese Government Collection.

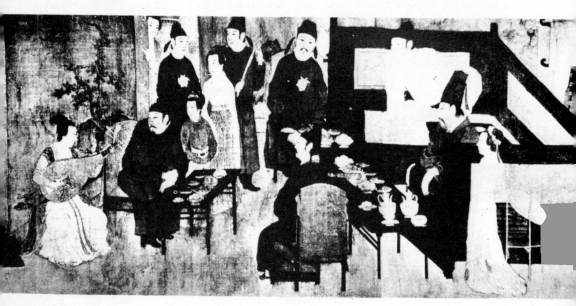

53. A perspective drawing derived from a single oblique projection.

54. A perspective drawing derived from a single isometric projection.

during which objects were drawn individually in either oblique projection or some approximation to isometric projection, but with a general tendency for the orthogonals to converge.

Drawings in perspective may be derived from drawings in one or other of the parallel systems by a number of different routes. Drawings of isolated objects in oblique projection may be changed into drawings in perspective by making the orthogonals converge instead of running parallel (fig. 53). Alternatively, drawings in perspective may be obtained from drawings in isometric projection (fig. 54).

The advantage of basing drawings in perspective on oblique projections is that the front faces of objects may be shown as true shapes. The disadvantages of these drawings is that they tend to conflict with the evidence of our senses. If an object is viewed directly from the front, so that the front face is seen as a true shape, only the front face will be seen. If the object is tilted, so that two or three faces can be seen, the front face will no longer appear as a true shape, although for small angles of tilt the distortion is hardly noticeable. This problem is avoided when drawings in perspective are derived from drawings in isometric projection, since drawings in isometric projection show the object in a foreshortened position in relation to both the scene and the viewer. However, the disadvantage of this system is that no face is shown as a true shape.

Instead of making the orthogonals converge within single objects, an effect of perspective may be obtained by combining two or more oblique projections in such a way that the orthogonals as a whole are directed towards the centre of the picture (fig. 55). This is the basis of *Night Entertainment*, and many Renaissance paintings. Here, the use of two oblique projections combined wins out over the use of isometric

55. An effect of perspective obtained by combining two oblique projections.

56. An effect of perspective is *not* obtained by combining two isometric projections.

projection: two isometric projections combined simply give an effect of two objects in foreshortened positions (fig. 56).

The problem with giving an effect of perspective using two or more oblique projections, however, is that when objects are set to the left and right of the picture, the conflict between the directions of the edges of the front faces of the objects in the picture and the evidence of our senses becomes more acute, since in real scenes, objects to the left and right are in foreshortened positions in relation to the viewer's line of sight as it is directed towards each part of the scene in turn. As White (1957) has pointed out, an attempt has been made to come to terms with this problem in the *Isabel of Bavaria and Christine de Pisan* manuscript painting (fig. 91). The bed on the right, and its canopy, are in separate versions of oblique projection, rather like the furniture in *Night Entertainment*; and an impression of perspective is obtained because there is a general convergence of the orthogonals towards the centre of the picture. In this picture, however, in contrast to *Night Entertainment*, the bed on the right and the couch on the left are shown in foreshortened positions, as they would appear to a viewer whose line of sight was directed to each part of the scene in turn.

For painters, the problem with this approach to perspective is that if the horizontals are extended (in this picture, the ends of the bed and the couch) they must meet in a curve. In the *Isabel of Bavaria* manuscript this potentially embarrassing configuration is masked by the central figures; but in Van Gogh's *Vincent's Room* (fig. 88), based on a remarkably similar composition, the curvature is frankly revealed.

At the beginning of the Renaissance the conflict between the use of more or less conventionalized rules, and the artist's attempt to portray faithfully what he could see, inevitably led to confusion. This resulted in pictures which contain characteristic

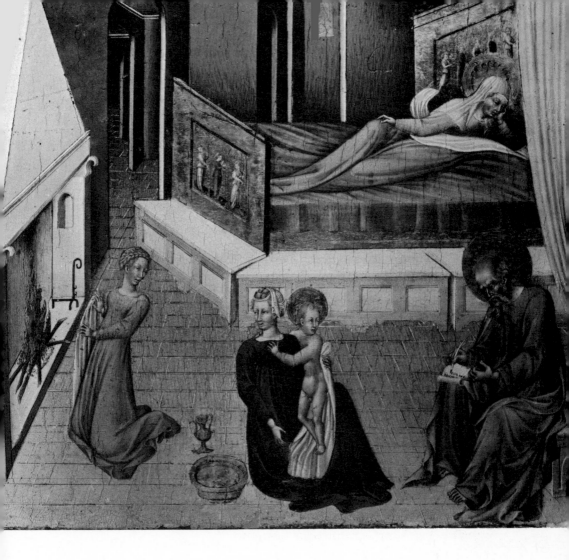

57. Giovanni de Paolo (active 1420, died 1482): *The Birth of St John the Baptist.* Oil on wood (predella panel from an alterpiece), 12.2 × 14.6in. [30.5 × 36.5cm.]. National Gallery, London. It is tempting to see in this picture the influence of Cennino Cennini's famous advice on how to paint buildings in perspective:

> And everywhere in your buildings observe the following rule: the mouldings which you paint at the top of the building must slope downwards towards the background. The moulding at the middle of the building, halfway up the facade, must be quite even and level. The moulding limiting the building at the bottom must appear to rise, contrary to the moulding at the top, which slopes downwards.

<div align="right">Cennino Cennini (c. 1312-?)</div>

In this picture, the top of the bed slopes downwards towards the background, while the bottom of the bed slopes up – but this is not quite what Cennini meant.

'errors'. In Giovanni de Paolo's *Birth of St John the Baptist* (fig. 57), for example, the orthogonals of the fireplace converge, while the bed head and foot are in separate versions of oblique projection, with the orthogonals running in conflicting directions. Like the traditional rules of grammar[1], the prescriptive workshop rules of perspective, developed at the beginning of the Renaissance, typically leave the most important underlying rules unexplained, and may even perhaps at times have added to the confusion, when they were followed blindly by an artist who perhaps did not understand their real significance.

Interior spaces obtained by combining oblique projections, so that the orthogonals converge towards the centre of the picture, often look octagonal. Many of the apparently octagonal buildings and spaces in paintings of this and earlier periods, as well as in Persian and Indian paintings, may have resulted from the combination of two opposing oblique projections. An apparently octagonal building seen from outside is obtained when a rectangular building is drawn in oblique projection with the orthogonals *diverging* (fig. 58). Of course, Cimabue may have intended to show an octagonal building in the first place; but the fact that the buildings on either side are shown in oblique projection with their orthogonals diverging makes it seem possible that the effect is the result of using a mixture of directions for the orthogonals.

However this may be, there are certain advantages in choosing octagonal buildings for demonstrations of perspective. If Cennino Cennini's advice (see fig. 57) is applied to a picture such as Cimabue's so that the mouldings at the top slope downwards instead of upwards, the sides of the building, instead of being faces at right angles to the picture plane shown in oblique projection, become faces at 45° to the picture plane, shown in perspective. This combines rather neatly the advantages of both isometric and oblique projections. The front face can be shown as a true shape (derived from oblique projection) while the side faces can still be seen, since they are shown in a genuinely foreshortened position at 45° to the picture plane, like the faces of a cube in isometric projection. It may have been fortuitous effects of this kind which induced Brunelleschi to choose the octagonal Baptistry at Florence for his famous demonstration (Chapter 5) – a choice which led on to the discovery of the formal rules of perspective, and Alberti's *costruzione legittima*.

58. A line drawing taken from Cimabue's *St Peter Healing the Lame*, second half of the 13th century, S. Francesco, Assisi.

5. *Perspective*

Euclid's *Optics* (*c.* 300 BC) deals in general terms with rays of light in space converging to a point at the spectator's eye; these rays constitute the visual pyramid or cone of vision. Euclid thus described the geometry of natural vision and natural perspective, rather than the geometry of pictures. An empirical form of pictorial perspective was, however, used in Graeco-Roman painting, as the first-century wall painting (fig. 59) shows. The orthogonals converge towards a central area; but there is no ground plane,

59. Fourth style wall painting (fresco), 1st century AD. House of the Vetti, Pompeii.

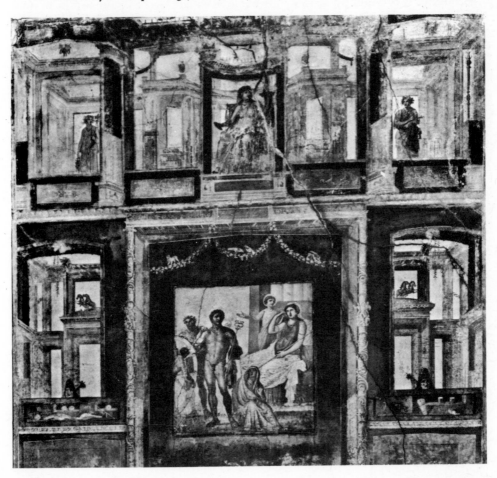

and it is the pictorial elements of overlapping and change of scale which contribute most to the illusion of space that is achieved in the picture.

It was not until the fifteenth century in Florence, when *artificial* or *scientific* perspective[1] was discovered, that artists were able to achieve a systematic representation of naturalistic space in pictures. The first known description of artificial perspective is by Alberti, in his *Della Pittura* written in 1436. In this work he defined: the picture plane (which he compared to a window frame); a fixed spectator point; the orthogonals; the eye level or horizon; the central vanishing point; the ground line; and the distance points. The procedures are methodically founded on theory and he was able, by using a chequered ground plan, to present a measurable space for the placing of figures. He called his method the *costruzione legittima*, and said, 'I have found this the best method'.

The problem which the *costruzione legittima* solves is the placing of the horizontal lines in a perspective representation of a chequered floor. These horizontal lines represent the edges of slabs or tiles running parallel to the picture plane, and are often referred to as *transvserals*. The simplest way of drawing a chequered floor in perspective is to begin by marking off a line of equally spaced points at the bottom of the picture. These points represent the front corners of the tiles or slabs which form the floor pavement. This line of points is called the 'ground line', and represents the front edge of the pavement where it intersects the picture plane. These points are then joined by straight lines to some point, arbitrarily chosen, somewhere about the centre of the picture. These straight lines are called the 'orthogonals', and they represent the edges of the pavement slabs at right angles to the picture plane. The point in the centre of the picture is called the 'central vanishing point'.

The problem now is to draw in the transversals, representing the edges of the pavement parallel to the picture plane. Before the fifteenth century painters attempted to do this by non-scientific means: one horizontal line was drawn in, at some arbitrary distance above the ground line, and then subsequent lines were put in by diminishing this distance, for each succeeding line of squares, by one third[2]. Alberti's contribution was to describe an accurate and scientific construction for putting in these transversals, using the distance point method, and to show that this was in accordance with the laws of optics. The fully articulated ground plan which could be achieved by these means was to be essential to the development of Renaissance painting, and enabled perspective to be understood in terms of both primary and secondary geometry.

Using the distance point method for obtaining the positions of the transversals, the orthogonals are first put in, in the normal way, by joining the front corners of the pavement to some arbitrarily chosen vanishing point. A horizontal line (the eye level or horizon line) is now drawn through the vanishing point and extended beyond the picture. A point is chosen at an arbitrary distance along the horizon line; this is called the distance point. Lines are now drawn from this distance point to the front corners of the pavement slabs; and the points at which these lines intersect a vertical line through the vanishing point mark the positions of the transversals[3].

The essence of this method, and its basis in primary geometry, is shown in figs 60 and 61. In fig. 60 the picture plane is placed vertically, with its base joined to the near side of a horizontal chequered pavement. Another plane containing V (the vanishing point) and SP (the spectator point) is set at right angles to the picture plane and passes through it at OO. The projection lines from the edges of the floor slabs pass through the picture plane to the spectator point; and as they do so, they form on the picture

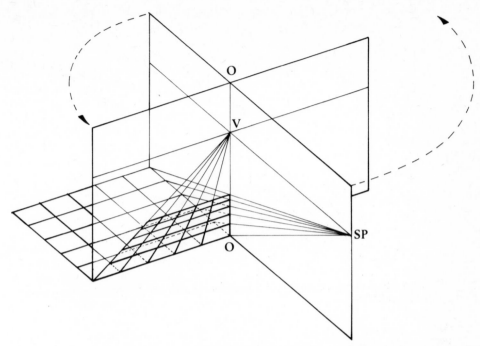

60. Trimetric drawing describing Alberti's distance point method.

plane an image of the edges of the pavement which are parallel to the picture plane. The lines representing these edges (the transversals) intersect the vertical line OO at the points where the projection rays pass through the picture plane. The orthogonals, which represent the edges of the floor at right angles to the picture plane, are formed by joining the front corners of the floor slabs to the vanishing point.

In fig. 61 the plane containing the spectator point SP has been folded back about the axis OO; and the spectator point now becomes the distance point DP. It can now be seen that the lines representing the projection rays must fall across the diagonals of the squares; and that the distance from the vanishing point to the distance point must be the same as the distance from the vanishing to the spectator point. Thus, the diagonals of a chequered floor converge to a distance point on the same level as the central vanishing point; and this distance point is the same distance from the vanishing point as the vanishing point is from the spectator point. Since the picture is, or can be, symmetrical, there is another distance point, again at the same distance from the vanishing point, on the other side of picture.

These diagonals in the picture represent, of course, the diagonals of the floor slabs, which in turn are at 45° to the picture plane. Thus, edges in the scene which are at 45° to the picture plane can be represented in the picture by lines which converge to distance points on either side of the central vanishing point. These distance points may thus be regarded as the vanishing points for edges at 45° to the picture plane: the edges of a building, for example, turned at 45° to the picture plane.

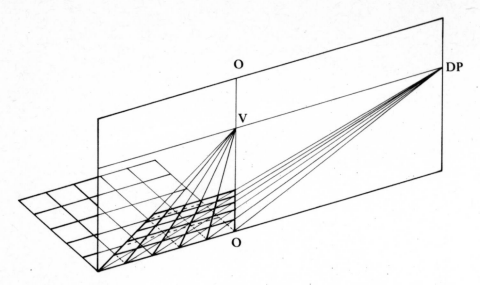

61. Drawing where the spectator point has been folded back about the axis OO to establish the distance point DP.

Although Alberti was the first to describe the distance point method, it seems unlikely that he invented or discovered it himself. Alberti's *Della Pittura* was dedicated to the Florentine architect Brunelleschi (1377–1447), and Manetti, in his *Life of Brunelleschi* (1480) attributes the invention of perspective to Brunelleschi 'in his early years before 1402'. Unfortunately there is no evidence from Brunelleschi's own hand, either in the form of writing or painting, to substantiate Manetti's claim. The attribution of the discovery of perspective to Brunelleschi, which has caused, and is still causing, endless debate among art historians and others, rests on the description by Manetti of a picture by Brunelleschi of the eastern side of the octagonal Baptistry in Florence – a picture which no longer exists.

The following are the main points of Manetti's description[4].

I. The panel on which the picture was painted was '*circa mezzo braccio quadro*'. This could mean either that the panel was a square with sides half a *braccio* square (i.e. that the sides of the panel were about 12in. [30.4cm.] wide), or that the area of the panel was half a square *braccio* (i.e. that the sides of the panel were about 16in. [40.6cm.] wide). If the latter were true, this would mean that the distance from the spectator point to the picture would be slightly increased, so that the viewing distance would be slightly more comfortable.

II. He showed 'a single view of the outside of the building'. This is not very helpful, and may mean simply that he showed only what could be seen from a single fixed viewing point.

III. His viewpoint when painting the picture was 'some three braccia' inside the west door of the cathedral. Given the width of the cathedral doorway, this

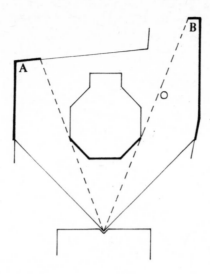

62. Plan of the piazza showing the Cathedral entrance in relation to the Baptistry (A: Pecore; B: 'Canto alla Paglia').

could mean that his lateral angle of view could have been anything up to 90° (White, 1957).

IV. The sides of the *piazza* were shown 'as far as the Pecore' on the left and 'as far as the Canto alla Paglia' on the right (fig. 62).

V. Brunelleschi directed the spectator to look through the painted panel from the back, where a peephole was made, so that the picture could be seen as a reflected image in a large mirror held in front of it. The peephole was 'as small as a lentil on the painted side' and the 'size of a ducat or a little more' at the back. This peephole was 'situated in the part of the church of Santo Giovanni where the eye struck, directly opposite anyone who looked out from that place inside the central door of Santa Maria del Fiore where he would have been positioned, if he had portrayed it'. In other words, the hole was made at the central vanishing point, suggesting Brunelleschi's awareness of the significance of the central vanishing point, and its relation to the spectator point in one point perspective. If the angle of view was 90°, the correct position for the mirror in front of the picture would have been either 3 or 4in. [7.6 or 10.2cm.] in front of the picture surface, depending on the size of the picture. This would give a reflected image 6 or 8in. [15.2 or 20.3cm.] wide (fig. 63).

VI. The sky in the painting, according to Manetti, was left unpainted, revealing a burnished silver ground 'so that the air and natural skies might be reflected in it, and thus also the clouds, which are seen in that silver, are moved by the wind when it blows'. The fact that the ground was burnished silver seems to lend support to the theory that the picture was produced by overpainting a mirror image.

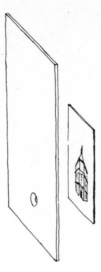

63. Drawing showing the relation of the two panels, the one with the hole being the painted panel.

VII. Manetti also comments on the 'care and delicacy' of the painting and the 'accuracy of colours of the black and white marbles'. In conclusion, he says, 'it seemed as if the real thing was seen: I have had it in my hand and can give testimony'.

Interpretations of Manetti's account

Manetti's account is open to many possible interpretations[5]. Much of the debate has centred round the question of the procedure which Brunelleschi might have adopted in order to produce his picture, and many plausible and ingenious solutions have been proposed. From a formal point of view, however, the question which has to be asked first is: what did Brunelleschi actually discover? After all, crediting someone with inventing or discovering perspective is rather vague. Did Brunelleschi, for example, discover that the orthogonals in a picture converge to a central vanishing point? This is what most people mean by 'perspective' and yet it seems rather a meagre interpretation. Another possibility is that Brunelleschi discovered a *procedure* for producing pictures in perspective (say, by overpainting a mirror image, or by tracing an image through a sheet of glass) without necessarily relating this to any geometric construction. Again, this seems rather a meagre interpretation. Another possibility – and this is the one which seems most likely to us – is that Brunelleschi discovered that the lines in a picture which represent edges at 45° to the picture plane must converge to points on either side of the central vanishing point (the distance points). In addition, Brunelleschi may have discovered that these points were equidistant from the vanishing point, and that the distance from these distance points to the central vanishing point was the same as the distance from the central vanishing point to the

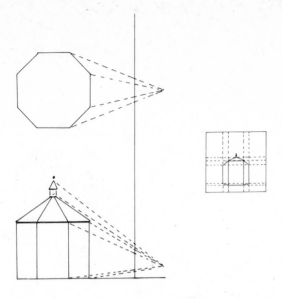

64. A drawing of the Baptistry made from plan and elevation. The network of intersecting lines establishes points on the picture to form the drawing.

spectator point. This seems to us the most likely possibility, for two reasons. First, this discovery is the essential component of Alberti's *costruzione legittima*, described in the *Della Pittura* which was dedicated to Brunelleschi. Secondly, the octagonal Baptistry, with its side walls at 45° to the picture plane, would have been the ideal vehicle either for making, or for demonstrating, this discovery.

The traditional questions about Brunelleschi's procedure in making his painting, posed by Manetti's account, may now be put in a new way. If what Brunelleschi discovered was the role of the distance points, what procedures might have led him to this discovery? Some art historians[6] consider that Brunelleschi obtained his perspective constructions by drawing plans and elevations of the primary geometry (fig. 64). According to Manetti, Brunelleschi was the first to introduce plans and elevations to Florence in the fifteenth century. The dimensions for these plans and elevations could have been obtained from buildings such as the Baptistry by direct measurement; alternatively they would have been obtained indirectly by using the surveying methods available at the time, perhaps involving the use of mirrors. Manetti states that in order to survey the ancient buildings in Rome, Brunelleschi used parchment strips, and transferred the measurements to paper. He might also have marked off coordinates on the edge of a mirror to obtain these measurements, since mirrors were used for surveying in the fifteenth century. According to Vasari:

Filippo Brunelleschi made a careful study of perspective, which because of all the errors of practice was in a deplorable state at that time and he worked for a long while until he discovered for himself a technique by which to render it truthfully and accurately, namely, by tracing it with the ground plan and profile and by intersecting lines.

(Bull, 1965, p. 136)

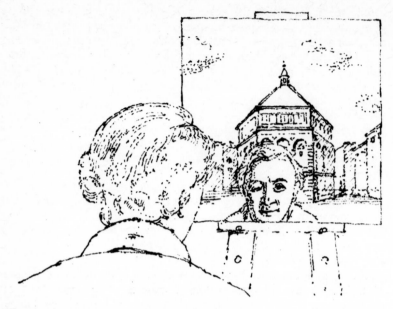

65. The spectator's head and reflection seen relative to the reflected image of the Baptistry.

66. Method of plotting points on a mirror surface using a stick.

If Brunelleschi did in fact adopt this procedure there would have been no need for him to put in either the central vanishing point or the distance points, since the image is produced, using this method, simply by connecting the points formed by the network of intersecting lines. Thus, although this does seem to be a procedure which Brunelleschi might have adopted, it seems unlikely that it would have led him to discover the distance point method; nor would the use of the octagonal Baptistry have had any particular significance, since the plan and elevation method can be used for buildings of any shape whatever.

If we are to believe that Brunelleschi produced his picture by painting over a mirror image, then he must have sat with his back to the Baptistry, using a sight vane or some other method to obtain a fixed eye point. In this case, how did he get over the problem of having his head in the way?

Some contestants in the 'who invented perspective and how' riddle consider this difficulty to be insurmountable. But the following experiment may prove that it is not so, even if the minimum viewing distance of 6 inches is used. If the observer stands with his eyes 6in. [15.2cm.] from the plane of the mirror and assuming that his head is of average size (say about 10in. [25.4cm.] high and 7.5in. [19cm.] wide) then the reflected size of the observer's head would be 5in. [12.7cm.] high and 3.75in. [9.5cm.] wide. The central vanishing point (the point 'where the eye struck') would have been towards the top and in the centre of the Baptistry doors, so that the lower part of the head would have been below the ground line, leaving the upper storey and roof of the Baptistry exposed in the mirror image[7]. This being the case, the essential geometric structure could easily have been plotted on the panel, certainly by moving the head and viewing alternatively with the left and right eyes (fig. 65).

The alternative to the use of a sight vane, with the discomfort of a fixed viewing position and the possible difficulty of getting one's head in the way, would have been for Brunelleschi to place a stick at right angles to the mirror at the required central vanishing point[8]. The tip of the stick[9] can be sighted at convenient distances away from the mirror against reflected points on the mirror surface, the true eye point (spectator point) being represented by the end of the stick (fig. 66). If this method was used, individual points on the image could have been plotted on the surface of the silver panel and joined up to form the drawing. Brunelleschi could then have noticed (a) that the sides of the *piazza* at right angles to the silver panel converged to a point where the stick entered the silver panel (where the eye struck) and (b) that the points representing the oblique receding planes of the Baptistry converged to points on either side of the centre (i.e. the distance points). It is also possible that he could have noticed that the distances from the central vanishing point, where the stick entered the panel, to the distance points, was the same as the length of the stick.

This method would also explain the reason for the hole in the panel[10], since it could have been left when the stick was removed; and Brunelleschi may well have hit on the idea of looking through it in order to see the correctly reversed image, reflected in the second mirror. If this account is correct, Brunelleschi's discoveries would have led directly to Alberti's distance point method; Alberti's contribution being to show the relationship (in terms of primary geometry) between the distance points and the spectator point. It is also possible that Alberti made the construction more general by relating the edges of the oblique faces of the building to the diagonals of a chequered floor.

There are differences of opinion concerning the size of the image of the Baptistry

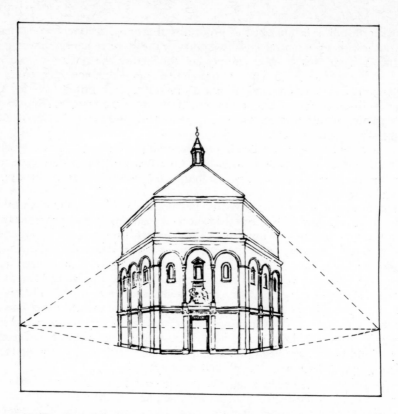

67. Drawing of the Baptistry where the viewing distance is 6in. [15cm.].

68. Drawing of the Baptistry where the viewing distance is 12in. [30cm.].

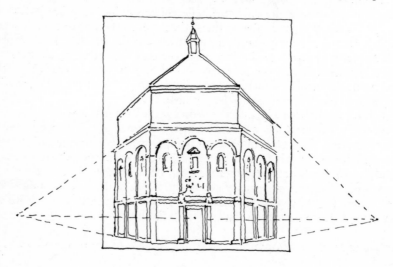

represented on the panel. The two principal views are (i) that the visual angle was 90°, making a viewing distance of 6in. [15.2cm.] and (ii) that the visual angle was about 53°, giving a viewing distance of about 12in. [30.4cm.].

Euclid's proposition 21 states that 'In similar triangles the ratios of corresponding sizes remain the same'. This would mean that whatever the viewing distance may have been, the ratios of measurements and angles of the building would remain the same, because the spectator stays where he is and only the picture plane (i.e. the mirror) is moved; rather as if a camera is set up on a tripod and a succession of shots taken of the subject, using a number of lenses of differing focal length; the scale changes, but again the ratios remain the same.

The drawings shown in figs 67 and 68 are an attempt to reconstruct alternative pictures of the Baptistry: in fig. 67 the viewing distance is 6in. [15.2cm.] and in fig. 68 the viewing distance is 12in. [30.4cm.]. The advantages of the 6in. [15.2cm.] viewing distances are that the distance points lie on the picture and that the building is surrounded by an airy and agreeable space. In fig. 68, where the viewing distance is 12in. [30.4cm.], the composition is overpowered by the building and the distance points occur, at great inconvenience, outside the picture surface.

Whatever process that may have been employed in conducting the demonstration, Manetti's account remains very attractive because of the number of important elements in the understanding of scientific or artificial perspective that are so beautifully illuminated.

Let us suppose that the topographical details that Manetti has supplied are correct, that the panel was made of burnished silver and that the dimensions were 12in. [30.4cm.] square. Also that Brunelleschi used a sight vane or a stick and stood with his back to the Baptistry using the panel as a mirror. If all of this is true, then the first three achievements of the demonstration were (i) to show that the spectator should use one fixed point for his observations, (ii) to show that in central perspective orthogonals converge to a single point and (iii) to show that the picture plane intercepts the visual cone. But by far the most sophisticated achievement would have been to have shown that the edges of the two oblique planes of the Baptistry at 45° to the picture plane converge to points on the horizon line equidistant from the central vanishing point; and that these distances are the same as from the spectator's eye point to the picture plane (i.e. the scale distance of the viewer from the front of the Baptistry).

A final question must be asked: did Brunelleschi choose the Baptistry with its cladding of black and white marble and its oblique walls at 45° deliberately, in order to emphasize his perspective skills and demonstrate the role of the distance points; or was the choice a happy accident, and the role of the distance points something he discovered while painting the picture? He was certainly in and around the cathedral at the time, pondering on another piece of business: how to construct the dome.

The interpretation given above is very attractive, because it is elegantly simple and ingenious, wrapping up so much in one small parcel, demonstrating the primary geometry and opening the window for Alberti to demonstrate the relationship between primary and secondary geometry. It is a pity that there is at present no shred of real evidence to support any part of Brunelleschi's contribution. Speculation goes on, perhaps something that Brunelleschi himself would have relished. The following extract from some remarks by Brunelleschi is very illuminating; he said,

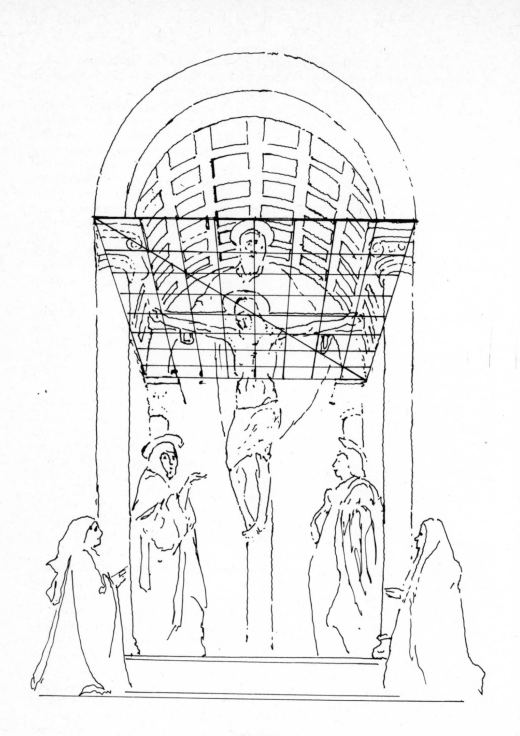

CVP

Do not share your inventions with many, share them only with a few who understand and love the sciences. To disclose too much of one's inventions and achievements is one and the same thing as to give up the fruits of one's ingenuity.

(Hyman, 1974, p. 31)

Masaccio's use of perspective

After the time of Brunelleschi's demonstration and before Alberti's book was written in 1436, Masaccio was painting frescoes in Florence, in the Brancacci Chapel and in Santa Maria Novella, and showing that he was in possession of the new learning of artificial perspective. In the fresco of the Trinity at Santa Maria Novella, Masaccio has demonstrated his awareness of the spectator's viewing position, by placing the horizon at the bottom of the first step in the picture, that is at the average spectator's eye level 5ft. 6in. [1m. 67cm.] from the floor, and so establishing a primary condition in the construction of an architectural illusion. To draw the coffered vault in the picture provides material for further supposition, since to make such a construction requires the use of a grid. Did Masaccio use a distance point construction for the grid as is shown in fig. 69, marking off equal intervals on the front edge, drawing the orthogonals to meet the central vanishing point, drawing a line from the near side right hand corner to meet the distance point and finding the horizontal intervals at the intersections with the orthogonals; or did he simply make a grid by the use of simple geometry, drawing a series of diagonals in the space defined by the four Ionic columns?

The drawing in fig. 69 shows that to find the intervals on the barrel vault, Masaccio produced lines from the central vanishing point (CVP) through the points on the near side of the grid to meet the arch; this accounts for the greater length of the coffering towards the sides of the arch. Because the floor is concealed from us, we are given no clues as to the position of the figures who occupy the central architectural space, apart from overlapping.

After the publication of Alberti's book, this viewer-centred system of representing space in pictures gradually became known in the studios of Europe, and was to be used by professional artists until the advent of Cubism at the latter end of the nineteenth century. At the present time perspective is taught in some art schools in a rather half-hearted and superficial way, not to be compared with the rigorous training that art students were subjected to in the past. Euclidean geometry, as a discrete study, is now rarely taught to children in schools; the fact that this skill and that of perspective drawing have diminished is perhaps not unrelated.

69. Drawing of Masaccio's fresco of the Trinity, showing the use of a grid.

6. *Mechanical aids to drawing*

In Dürer's treatise on measurement, published in 1525, there are four illustrations of drawing machines. These are directly related to Brunelleschi's practical demonstration and Alberti's definition of the picture plane as a window: a plane or window in space where the spectator decides that he will intercept the visual rays that converge on to his retina. Dürer's machines also demonstrate the necessity for maintaining a fixed spectator point (sometimes called the station point or observation point).

Method of drawing a portrait

In fig. 70 the artist is seen drawing a seated man on a pane of glass, keeping his eye in one place by looking through a sight vane. 'Such is good for all those wishing to make a portrait but who cannot trust their skill', recommends Dürer. The artist simply

70. Albrecht Dürer: *Method of drawing a portrait*. Woodcut, 5.1 × 5.9in. [13 × 14.9cm.]. From *Underweysung der messung*, Nürnberg, 1525.

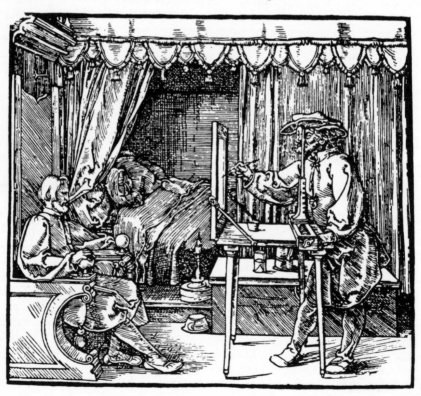

traces the contours that appear on the glass, with a paint brush. The drawing that results is transferred to a panel ready for painting.

There is a drawing of a similar machine in one of Leonardo's notebooks; probably Dürer learnt of the device when he met Leonardo in Venice.

By using a window with a view, closing one eye and keeping the head still, it is possible for anybody to demonstrate the principle of the machine. A chinagraph pencil or white paint may be used for tracing the outlines.

A man drawing a recumbent woman

Again the spectator keeps his eye in one place by using the sight vane. The frame (picture plane) is here covered with a network of lines; squared up like a map. The spectator's drawing paper is also squared up, not necessarily to the same scale. As the contours are observed in relation to squares within the frame, these contours can then be drawn on to the corresponding squares on the paper. By using this method, Dürer shows the man overcoming the difficulties involved in a close-up foreshortened view, also that this is a good method for reducing or enlarging a drawing proportionally (fig. 71).

71. Albrecht Dürer: *A man drawing a recumbent woman*. Woodcut, 2.6 × 7.2in. [6.5 × 18.3cm.]. From *Underweysung der messung*, Nürnberg, 1536.

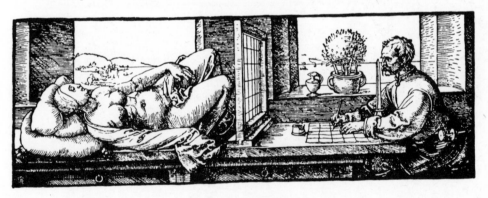

A man drawing a vase

In 'method of drawing a portrait', the spectator is restricted to the size that he can make his drawing by the length of his arm plus the brush. When light rays converge to the spectator's eye, the size of the image formed by the intersection of these rays on the glass or picture plane is the size that can be seen, so the drawing is sight size. Sight size can be infinitely variable and depends on the distance between the spectator, the picture plane and the object. 'A man drawing a vase' method (fig. 72) extends the possibilities of size and spectator distance from the picture plane, by substituting a ball and socket joint attached to the wall for the visual cone. The use of a rigid bar with a plain sight at the operator's end and the ball and socket at the other end simulates a single ray of light. The operator aims at the vase, tracing the contours on to the glass,

72. Albrecht Dürer: *A man drawing a vase.* Woodcut, 2.8 × 7.2in. [7 × 18.2cm]. From *Underweysung der messung*, Nürnberg, 1538.

73. Albrecht Dürer: *A man drawing a lute.* Woodcut, 5.1 × 7.3in. [13.1 × 18.3cm.]. From *Underweysung der messung*, Nürnberg, 1525.

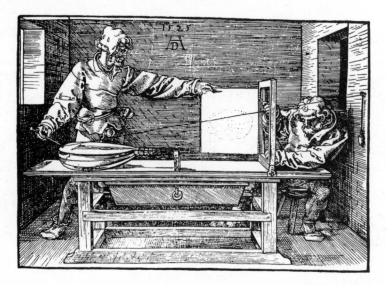

moving his head with the contour because the bar is rigid. The machine is nicer in theory than in practice, although perhaps a skilled operator could produce good results.

A man drawing a lute

This method (fig. 73) also provides for those who require long-distance projection; and it removes the tiresome business of looking through a sighting device. It does, however, require two operators, one for calculating and one for drawing. A simple pulley is attached to the wall, a piece of string passes through the pulley with a weight

at one end and a pointer at the other end. The pulley is substituting for the spectator's eye, the apex of the cone of vision. The string from the pulley to the pointer represents a single ray of light and passes through the picture plane. As the man with the pointer fixes different reference points on the lute, his assistant measures off the vertical and horizontal coordinates and plots each new point on the drawing. When there are enough points, he joins the relevant ones, and completes the drawing.

Dürer's machine has its counterpart in modern computing equipment. In the two-dimensional versions, a sighting device or 'hedge-hog' is run around lines or contours by hand. The coordinates of a very large number of points along the lines are automatically recorded on magnetic tape. After filtering, these coordinates may be transformed by computer, according to any projection system, and the result displayed on a cathode ray tube or line plotter.

The camera obscura

The camera obscura was first used for observing eclipses; it was not until the mid-sixteenth century that Giovanni Battista della Porta popularized its use as an aid for artists. Subsequently over the next three centuries many variations of the camera obscura were designed and made[1]. A typical eighteenth-century model consists of a mirror at the top, a double convex lens and a small dark enclosure. The observer places his head and hands inside the enclosure making sure that no unwanted light enters and stands with his back to the subject. An image of the subject being observed is deflected by the mirror through the lens and on to the paper at the bottom of the enclosure, where the observer may trace round the contours of the projected picture. Sir Joshua Reynolds used a collapsible version of the model illustrated which folded into a box resembling a leatherbound library folio, now in possession of the Science Museum, London.

A variation of the camera obscura was adapted by Fox Talbot for photography; the first photographic camera was a single-lens reflex.

The Academic life class

The Royal Academy Schools removed to Burlington House in 1869. Working presumably on the excellent principle of 'finding something good and sticking to it', the drawing school is even now remarkably like the one shown in the engraving by Rowlandson, *The Life Class in the Royal Academy Schools at Somerset House* (1811) (fig. 74). The Somerset House School in its turn copied the design from Sir Thomas Thornhill's St Martin's Lane Academy.

The seating arrangements consist of a treble row of fixed benches forming a semicircle; at the centre of the arc is the model's throne. The daylight comes from one direction only, a most important amenity. Students who wish to draw the full figure may sit 18ft. [6m.] away from the model at the raised outer perimeter of benches, and those wishing to draw a seated figure or a detail sit at the lower inner perimeter. Thornhill was a painter who worked in, and thoroughly understood, the Grand European tradition, and in designing his drawing school he clearly had Leonardo's advice in mind: 'When you have to draw from nature, stand at a distance three times the size of the object you draw.'

When a standing figure is drawn at the Royal Academy Schools, the draughtsman

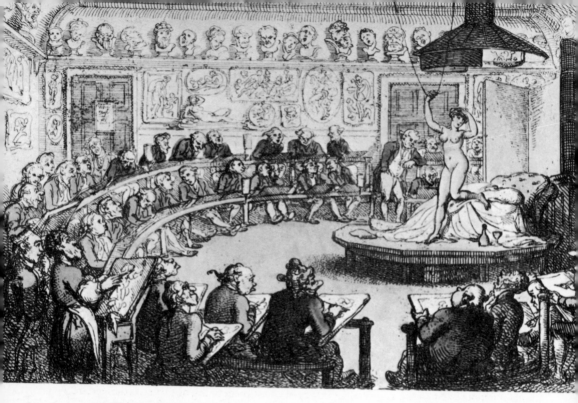

74. Thomas Rowlandson: *The Life Class at the Royal Academy School at Somerset House*, 1811. Etching, 5.75 × 8.5in. [14.5 × 21.6cm.]. Royal Academy, London.

sitting 18ft. [6m.] away from the model, drawing board 18 to 20 in. [45.7 to 50.8cm.] from his eyes and making the drawing sight size, the figure on the paper will measure from 6 to 8in. [15.2 to 20.3cm.] high. The draughtsman will then be taking advantage of the natural communication between eye and hand, drawing the size that he can see and consequently helping to avoid common difficulties like incorrect proportion, empty forms, and most of all multiple cones of vision.

The camera lucida

The camera lucida (fig. 75) was invented by William Hyde Wollaston in 1807, at a time when there was a decided movement in painting towards greater naturalism, and it was used by a number of artists. The camera lucida achieves similar results to the camera obscura and has the advantage of being readily portable. In its little box it can be carried in a coat pocket; but it has the disadvantage of being tiresome to use as the spectator has to close one eye and keep the machine and the drawing board quite rigid.

The most important component is a four-sided prism, to which is attached a sighting device in the form of a piece of metal with a small aperture. Between the prism and the paper on the drawing board there is a lens which helps to bring the object and the paper on to the same apparent plane. The prism is held in a simple casing open on two sides and attached to a piece of movable tubing. The observer faces the object he wishes to draw, having his drawing board and camera lucida firmly fixed and the

75. A camera lucida made early in the 19th century.

76. Drawing of an oil lamp made by using a camera lucida.

drawing board lying parallel to the ground. He then places his eye close to the aperture in the sighting device, which is adjusted so that half of the aperture reveals rays from the object through the prism, the other half revealing rays from the paper. The observer can see a reflected image of the view in front of him, apparently lying on the paper, at the same time seeing the tip of his pencil on the paper well enough for him to be able to copy the apparent image. The most complex topographical perspective view can be recorded with great accuracy. The size of the image depends on the spectator's distance from the paper, which is governed by the length of the movable metal tubing; drawings are therefore sight size. The visual angle is narrow, between 20° and 25°.

Fig. 76 shows a drawing of an oil lamp made with a camera lucida.

The photographic accuracy of Vermeer's paintings

Before discussion can begin concerning Vermeer's *The Music Lesson*, it is necessary to understand a property of the 'distance point' that was explained by Leonardo. He showed how to obtain information about the position of objects in space by linear measurements taken from paintings and drawings. He wrote,

> If you draw a plan of a square (in perspective) and tell me the length of the near side, and if you mark within it a point at random, I shall be able to tell you how far is your sight from that square, and what is the position of the selected point.

<div align="right">(Booker, 1963, p. 28)</div>

Leonardo then goes on to explain the procedure; an adaptation of the method is as follows. (In Leonardo's description of the procedure, the central vanishing point V and the side of the picture plane VG are not in coincidence; the result, however, is precisely the same.)

Take a square ABCD in perspective (fig. 77). Produce AD and BC to intersect at V. The point V is the central vanishing point (on the horizon or eye level). Produce the diagonal AC to meet the eye level; this gives the distance point DP. Mark off a number of equal divisions along AG passing through B. Join these points to DP and V. The intersections on VG will give the horizontal coordinates and the intersections along AB will give the orthogonal coordinates. 'Scale your drawing', Leonardo says, 'and you will see the position of your point marked at random in the square.'

<div align="center">77. Leonardo's method.</div>

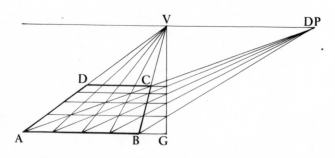

Vermeer

In 1629, three years before Vermeer was born, an extensive work on perspective was published in Amsterdam by Samuel Marolois in which the principles that were laid down by Alberti were restated and elaborated. During Vermeer's working life in Holland, Descartes was inventing coordinate geometry and Spinoza was making the best lenses in Europe for telescopes and microscopes; from this time optical instruments were to become increasingly efficient.

This age of reason, when art and science were happily married, was characterized by measurement; measurement in terms of observation and measurement in terms of mathematics.

Vermeer, of all seventeenth-century artists, strove to achieve complete identity with

78. Johannes Vermeer: *The Music Lesson (A Lady at the Virginals with a Gentleman)*, *c.* 1665-70. Oil on canvas, 29 × 25.3in. [73.7 × 64cm.]. Royal Collection, The Queen's Gallery.

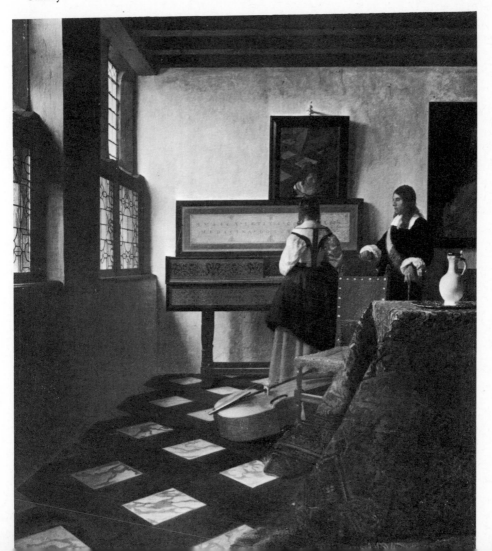

his subjects. It is therefore apposite to scrutinize and measure one of his pictures, *The Music Lesson* (*c.* 1665–70, 29in. × 25.5in. [73.7cm. × 64cm.] fig. 78). For linear measurements of a painting or photograph it is necessary to work perspective backwards, by Leonardo's method (fig. 77). (All measurements are quoted as they would be from the painting itself.)

1. Find the vanishing point at the intersection of the orthogonals.
2. Draw a horizontal line (eye level) through the vanishing point.
3. Extend the edges of the diagonally patterned squares on the floor to intersect the eye level.
4. Measure the distance from these intersections to the distance point: 27.6in. [70cm.] one side and 29.6in. [75.2cm.] the other side.
5. These distances should be equal; if they are not, take the mean, 28.6in. [72.6cm.]. This is the distance of the spectator (Vermeer) from the canvas. The discrepancies between the points where the squares converge on the eye level may be attributed to lens distortions or inaccurate drawing either by Vermeer or ourselves.
6. Measure the height of the lady in the painting, 10.2in. [25.9cm.].
7. Assume that her real height is 5ft., i.e. 60in. [152.4cm.]. In this case a guess based on the probability that Dutch gentlewomen in the seventeenth century were not generally very tall.
8. Let her real distance from the spectator be D inches.
9. Then by simiilar triangles (fig. 79):

$$\frac{D}{60} = \frac{28.6}{10.2} \quad D = 168in.$$

$$\left[\frac{D}{152.4} = \frac{72.6}{25.9} \quad D = 426.7cm.\right]$$

10. Measure the length of the diagonal of a square on the same level as the lady, 2.4in. [6.1cm.].
11. The real length of this diagonal must be

$$2.4 \times \frac{60}{10.2} = 14.1in.$$

$$\left[6.1 \times \frac{152.4}{5.9} = 35.9cm.\right]$$

12. By counting the squares on the floor in the painting, a ground plan of the room may be drawn up.
13. Draw in the picture plane and the spectator point on the plan.
14. Draw in the visual angle. This should meet the corner between the floor and

the left-hand wall at the point shown in the painting, providing an independent check of the system and the assumption made about the lady's height.

15. In this case the agreement is good; if it is only fair then the process from (6) must be repeated, making a new assumption: this process must be continued until the necessary accuracy is obtained.

16. To find the dimension of any other object in the painting, compare its measurements with those of a square at the same distance in space from the spectator. If the picture length of the diagonal of the square is **L**, and the picture measurement of the object is **m**, and the true measurement of the object is **M**, then:

$$\frac{M}{m} = \frac{14.1 \text{in. } [35.9\text{cm.}]}{L}$$

$$M = 14.1 \text{in. } [35.9\text{cm.}] \times \frac{m}{L}$$

17. By this means the size of any object in the painting may be found and the plan and elevation views drawn, providing all the necessary information for an axonometric drawing (fig. 80) or even a *tableau vivant*.

As we shall see (fig. 87), when the visual angle exceeds about 25° distortions occur towards the edges of the pictures. In *The Music Lesson*, where the visual angle is 45°, the squares at the bottom of the picture begin to distort. Vermeer disguised this on the right-hand side of the picture by covering the squares with a carpet, and on the left-hand side by cutting the squares with the picture frame. The disadvantages of possible distortions were probably carefully weighed against the feeling of intimacy that he achieved by drawing the spectator into the room, to sit by the table and observe the music lesson. The plan also reveals the care with which Vermeer placed the objects on the room. Note how the harmony of movement in space is obtained by placing the figures and the furniture either parallel to the picture plane or following the diagonal pattern of the squares on the floor.

The calculations may be checked optically by using a similar tracing apparatus to

79. Similar triangles: the height and distance of the lady in the painting compared with the height and distance of the real lady in the scene.

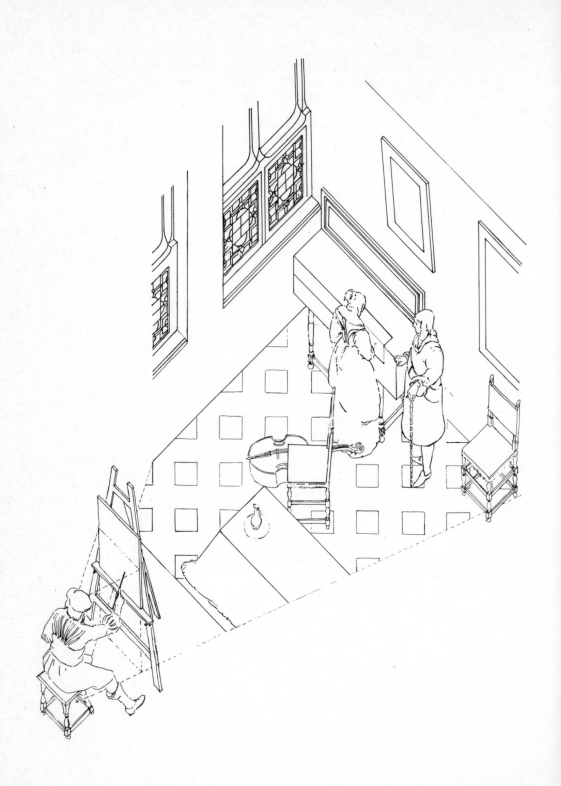

fig. 70, with a fixed eye piece at 28.6in. [72.6cm.] from the picture plane, and employing the services of a 60in. [152.4cm.] lady standing 168in. [426.7cm.] from the eye piece. It will be seen that Vermeer painted *The Music Lesson* sight size; and the image of the lady on the screen will be 10.2in. [25.9cm.] which is the same as in the real painting.

The photographic accuracy of Vermeer's paintings suggests that he may have used a camera obscura; there are, however, practical difficulties involved in using one in poor lighting conditions indoors. Even now, when large lenses are relatively cheap, the subject requires considerable illumination for an image to be clearly visible; the softly modulated lighting that is found in Vermeer's pictures could not have been observed in a camera obscura. Another possibility is that Vermeer (and perhaps Rembrandt and Velazquez) made use of mirrors[2]. This would have helped them to obtain an accurate drawing on the mirror, to reduce the scale of the subject (very necessary, as studios were often quite small) and to close up the tone values (silver, not mercury, was used as a reflector in the seventeenth century, causing a 30 per cent reduction of the light received).

If Vermeer used a mirror for *The Music Lesson* he would have been seated close to the table in the foreground of the picture with his back to the scene; in addition he would have had to exclude himself from the picture. The essential geometry that has been described in the preceding account would, however, remain the same.

80. Axonometric projection derived from *The Music Lesson*.

7. Long spectator distance and shallow field of focus

These pictorial devices are used particularly by mural painters where the viewer is able to see pictures as an illusion of believable space, either at a considerable distance or from unusual angles. Here we shall discuss other reasons for using these devices by three easel painters, Caravaggio, Canaletto and David.

Caravaggio

There is a fine balance between monumentality and intimacy in Caravaggio's *The Supper at Emmaus* (fig. 81). The feeling of being a witness to an intimate event is brought about by such devices as the place at the table awaiting another chair; the fruit basket that may topple over; the chair on the left being informally cut off by the picture plane; and the painting of the life-size figures. On the other hand the breadth of

81. Michelango Caravaggio (1573-1610): *The Supper at Emmaus*. Oil on canvas, 55 × 77.5in. [139 × 195cm.]. National Gallery, London.

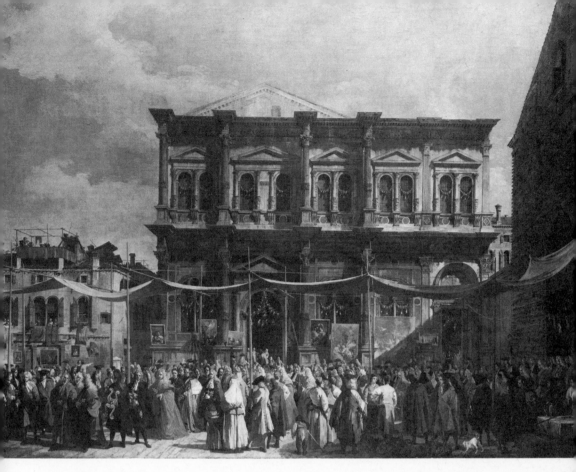

82. Antonio Canaletto: *Venice: The Feast of St. Roch, c.* 1727. Oil on canvas, 58.1 ×
78.5in. [147.7 × 199.4cm.]. National Gallery, London.

handling, solidity and especially the minimal change of scale between one like form
and another, combine to characterize the monumental qualities in this picture. For
example, the outstretched hands of the disciple on Christ's left (presumably Peter) are
nearly the same size even though he appears to be almost touching the picture plane
with one hand, and the wall behind Christ with the other. Such minimal change of
scale is only possible when the subject is viewed from a considerable distance, as in
photography using a telephoto lens or as seen through a telescope, when the system
approaches orthographic projection.

A central projection system has been used, yet only one true orthogonal is revealed,
on the right-hand side of the table; this creates difficulties over discovering the exact
position of the centre of vision. However, the bowl on the table can be 'crated' in order
to make a square so that Leonardo's method may be applied. A very rough estimate
using this method indicates that the spectator point is about 17ft. [5m.] from the
picture plane (the size of the picture is 55in. × 77.5in. [139.7cm. × 196.9cm.], giving
a visual angle of about 22°).

The narrow depth of field, from the picture plane to the wall, and the relatively long
spectator distance combined with the narrow visual angle overcome the difficulties

associated with motion parallax that Caravaggio would have been aware of in painting a group of life-size figures. *The Supper at Emmaus* almost approaches Leonardo's ideas on simple perspective, where the subject is equally distant from the eye in every part.

Canaletto

Canaletto's first training was in his father's profession of scenography, and his *The Feast of S. Roch* (fig. 82) could be the setting for a theatrical performance staged on a grand scale in a great metropolitan opera house. The scene is typically Venetian, where the religious, social and commercial life is a public rather than a private affair, and is carried on in a noble building. As in most of Canaletto's paintings the angle of vision here is wide, but he managed to avoid problems of distortion by confining the subject matter of the picture to the middle and far distance, and in this particular painting using a shallow field of focus. The effect of this can be seen towards the edges of the painting. The drawing of the little loggia on the left of the painting is virtually in oblique projection; if the orthogonals had noticeably converged then the distortion would have been disturbing. Canaletto's paintings display remarkable skill in topographical draughtsmanship combined with a complete understanding of the perspective devices that he used with masterly assurance. This was an age where perspective was studied with almost passionate interest; Andrea Pozzo (who painted the ceiling of the Jesuit church of St Ignazio in Rome) published in 1707 a work on perspective called *Perspectiva Pictorum* which was translated into several languages and was a source of inspiration to many artists including Sir Joshua Reynolds.

David

The feeling of discontent in France in the late eighteenth century which brought about a reassessment of artistic, moral and political standards, culminated in the revolution of 1789. The painter Jacques Louis David was deeply involved in these events. In the eighteenth century, as the result of discoveries at Herculaneum and Pompeii, the classical style in dress, furniture and decoration became fashionable. In painting the school of Neo-Classicism was born, with David at the head. In the painting *Madame Verniac* (fig. 83) the same perspective devices are used as in Caravaggio's *The Supper at Emmaus* – a long spectator distance, an extremely narrow angle of vision and a shallow field of focus. Again the painting is monumental but, unlike *The Supper at Emmaus*, the subject is formal and the paint dry and arid.

By using these devices the artist was able to distance the sitter from the spectator, and thus to suggest that he or she belonged to history rather than to the everyday world.

Napoleon embraced Neo-Classicism with enthusiasm and surrounded himself with furniture and trappings of this style; he also sat to David for a picture of himself crossing the Alps on a white charger: no doubt he relished the idea of a parallel between himself and Hannibal.

David's pupil Ingres carried the Neo-Classical tradition on into the nineteenth century, in contrast to the romanticism of Delacroix and Géricault who, like producers of cinema epics, were constantly seeking to involve the spectator intimately in stirring events.

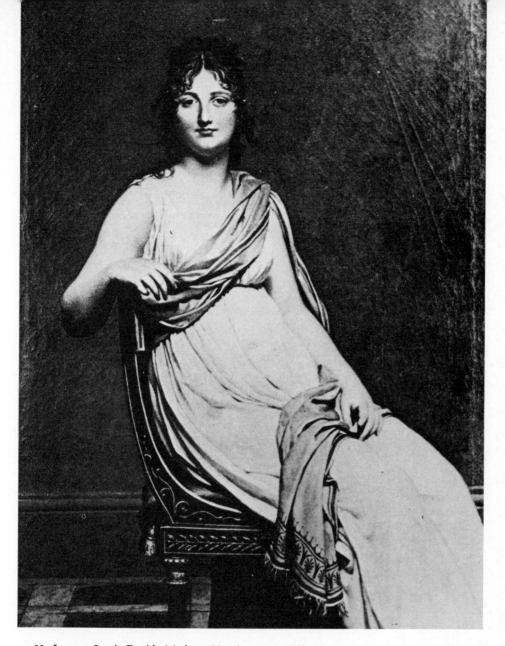

83. Jacques Louis David: *Madame Verniac*, 1799. Oil on canvas, 57 × 44.1in. [145 × 112cm.]. Musée du Louvre, Paris.

During the nineteenth century artists working in the classical tradition of David tended to move the spectator further and further away from the picture plane. The logical outcome of this was to move the spectator to infinity (away from a fixed spectator point) and to place all the emphasis on the reality of the object in itself, divorced from any particular point or direction of view, as in a Cubist painting (Chapter 10).

8. *Wide angles of view*

Most people take it for granted that pictures in true perspective are 'realistic': that is, that they give us a view of the world which is similar to that which we obtain from the real world itself[1]. However, even pictures in true perspective seem distorted, unless the angle of view for the picture is fairly small. This angle of view is the angle subtended by the greatest width of the picture at the spectator point. When this angle begins to exceed 25° distortions begin to appear at the edges of the picture; these distortions may be more or less obtrusive, depending on the subject matter of the picture, and the shapes and positions of objects in the picture relative to the picture plane. Distortions of this kind have bothered artists and designers since the beginning of the Renaissance, and continue to bother them to the present day. Architectural students, for example, are often disconcerted to find that their perspective drawings look subtly wrong, even when they have been correctly developed from plans and elevations.

84. A perspective projection of a row of columns, using normal artificial perspective.

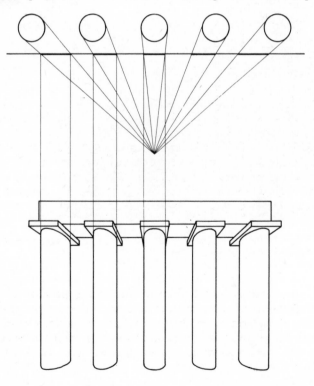

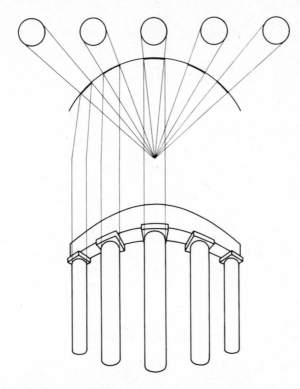

85. A perspective projection of the same row of columns, using a curved picture plane ('synthetic perspective').

The classic, and perhaps the earliest, account of this problem was given by Leonardo da Vinci (1452-1519) in the form of what is known as 'Leonardo's Paradox'. Imagine a row of equally spaced columns opposite a viewer at a fixed point. The viewer's experience, as he looks down the line of columns to either side, will be that the columns will appear smaller as they get further away. Now imagine a picture of this scene in artificial perspective, with the picture plane parallel to the columns and the spectator point at the viewer's centre of vision (fig. 84). The diagram shows that the projected widths of the columns get *larger* instead of smaller as the columns get further away, in direct conflict with the viewer's experience. Moreover, the *heights* of the columns on the picture surface get neither smaller nor larger, but remain the same, however much the picture is extended.

One way out of this difficulty which has often been proposed is to use a curved picture plane (fig. 85), with the centre of curvature at the spectator point. Sure enough, the widths of the columns projected onto this picture plane do get smaller as the columns get further away. This appears to agree with normal experience, and, of course, remains true if this curved picture plane is rolled back on to a flat surface. Moreover, the heights of the columns also diminish on the picture surface as they get further away, which again seems to be in accord with the way in which we normally experience the real world. Unfortunately, however, a new problem arises: edges at

right angles to the viewer's principal line of sight, such as the edges of the beam along the top of the columns, must now be drawn as curved lines.

These difficulties have led to a tremendous amount of confusion. Proponents of the second approach[2] have often claimed that the use of a curved picture plane gives results which are somehow truer to what we really see; and the analogy between a curved (or spherical) picture plane, and the curvature of the retina is often invoked (quite irrelevantly) in support of this argument. Unfortunately, this leaves proponents of the approach with the problem of explaining why it is that straight edges have to be drawn as curved lines. The usual retort is that we do actually *experience* straight edges in the real world as curved: either in the normal everyday world (which seems contrary to common experience) or in some heightened state peculiar to artists.

The truth of the matter is that both *artificial* perspective (which depends on using a *flat* picture plane) and *synthetic*[3] perspective (which depends on using a *curved* picture plane) are alternative ways of mapping the real world on to a two-dimensional surface. Neither system can be said to be true either of the way the real world *is*, or true of the way in which we *experience* the real world, in any absolute sense[4]. Historically, as White has pointed out, both systems have been used by artists throughout the Renaissance; and both systems continue to be used up to the present day, although artificial perspective is by far the more common. Both systems have

86. Pieter Saenredam (1595-1665): *The Grote Kerk at Haarlem*. Oil on panel, 23.5 × 32.1in. [59.5 × 81.7cm.]. National Gallery, London.

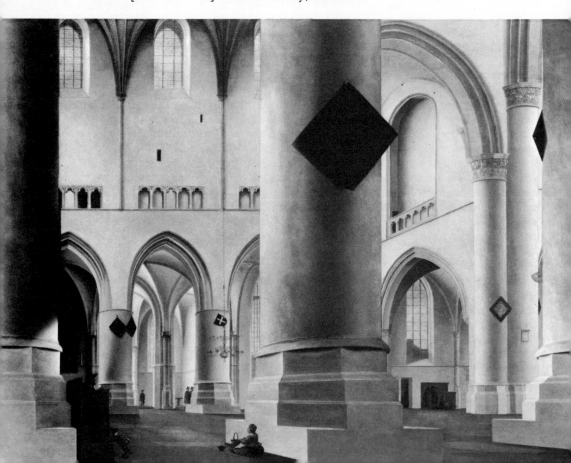

inherent advantages and disadvantages, mainly associated with the apparent distortions which they produce when the angle of view is fairly large.

One obvious but perhaps rather timid way of avoiding these distortions is to keep the angle of view fairly small. Leonardo's advice was that the spectator should place himself at a distance equal to three times the length of the longest dimension of the object to be drawn, in order to avoid unnatural distortions. This results in a visual angle of about 20°, which is well on the cautious side: in photography, the nearest equivalent to a visual angle of 20° is obtained by using a telephoto lens of about 120mm. on a 35mm. camera.

Another approach is to avoid using objects with strongly marked geometric shapes, or to concentrate these objects towards the centre of the picture. The distortion of objects having irregular shapes, though still of course present towards the edges of the picture, will often be less noticeable than the distortions of objects with regular shapes. The distortions of rectangular objects such as chairs or tables are particularly obtrusive towards the edges of the picture if these objects are shown in foreshortened positions, when they approximate to foreshortened views in oblique projection (fig. 50).

Yet another approach is to insist that the picture is viewed monocularly from the spectator point. This restriction is usually unenforceable in practice, unless the spectator has to look through a peephole in order to see the picture at all. When this restriction *is* enforceable, however, the shape of the picture plane becomes irrelevant, provided the images on the surface have been obtained by projection to the spectator point. In van Hooganstraaten's delightful peepshow in the National Gallery, the objects in a series of rooms have been projected on to the interior surface of a rectangular box; but they could equally well have been projected on to a box with curved surfaces, or surfaces of any other shape, to give a similar effect.

Another, and perhaps more subtle, approach is to disguise the distortions so that the spectator does not notice them. The greatest master of this approach was the Dutch artist Pieter Saenredam (1595-1665). Saenredam was a trained architectural draughtsman, accustomed to making drawings from measurements, which was the way he prepared the cartoons for his paintings (Carter, 1967).

At first glance, from a viewing distance of about 8ft. [2.5m.] away, Saenderam's *The Grote Kerk at Haarlem* (fig. 86) seems to be a rather ordinary painting in straightforward artificial perspective, with the rows of columns in the foreground shown parallel to the picture plane. However, the spectator point is nowhere near 8ft. away; nor is it opposite the centre of the picture as one might expect. If the orthogonals representing the edges of the base of the centre column and the mouldings on the side wall of the church are extended, they meet at a point only 2in. [5cm.] to the right of the left-hand edge of the picture, and only about 4.5in. [11cm.] above the bottom edge: that is, the central vanishing point is almost at the bottom left-hand corner of the picture. The station point, and hence the spectator distance, may be found by a method similar to that described for Vermeer's *The Music Lesson* (Chapter 6). The bottom edges of the base of the central column are drawn in, so as to complete the square base, and the diagonal of this square is then drawn in so as to intersect the horizontal line through the central vanishing point. This intersection marks the station point, and is 15.75in. [40.0cm.] from the central vanishing point; so the spectator point is 15.75in. from the picture surface, and almost opposite the bottom left-hand corner of the picture.

If the picture is viewed from the correct spectator point it seems to undergo a

miraculous transformation. The spectator seems to be looking up and to the right into a real interior; and instead of the row of columns being seen frontally, they recede at an apparent angle of about 45°, so that the base of the central column, which in the picture approximates to an oblique projection, is now seen in isometric projection. Something of this effect can be experienced by viewing the reproduction in this book monocularly, with the open eye at about 3in. [7.6cm.] from the picture surface; but the small size of the reproduction makes it difficult to focus in the picture. An enlarged reproduction or a colour slide would be better; best of all of course is to look at the original picture, which, together with another painting by Saenredam, is in the National Gallery in London. Yet another painting by Saenredam in which a similar effect may be observed is the *Cathedral of St John at S. Hertogenbosch* in the National Gallery of Art in Washington, D.C. Here again the spectator point is very close to

87. A plan of the three columns shown in *The Grote Kerk at Haarlem*, and a perspective drawing derived from the plan, showing the position of the spectator point.

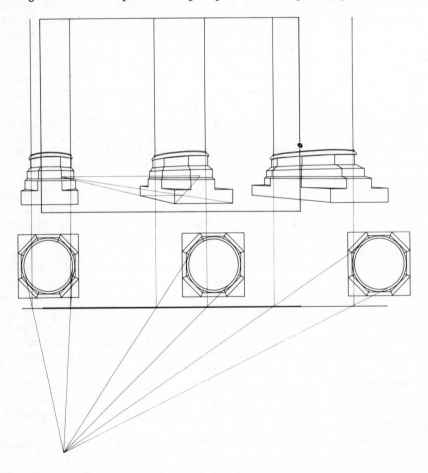

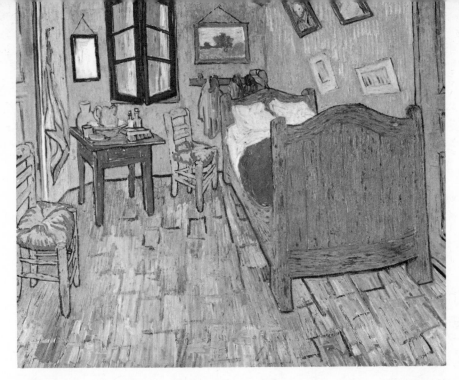

88. Vincent van Gogh: *Vincent's Room*, 1888. Oil on canvas, 28.5 × 36in. [72.4 × 91.4cm.]. The Art Institute of Chicago.

the picture; but in this picture the spectator looks directly upwards into the interior of a semi-circular apse.

The position of the spectator point may be used to establish the positions of the bases of the columns shown in *The Grote Kerk at Haarlem* and so to complete the columns cut off to the right and left of the picture. When this is done (fig. 87) it is apparent that if the whole of the right-hand column had been included in the picture, it would have looked wildly distorted.

Thus, though Saenredam used an exceptionally wide angle of view, the distortions inherent in the picture are not noticeable at first glance. The distortion of the right-hand column is disguised by concealing most of the column behind the right-hand picture frame. What remains in view is about equal in width to what remains of the column on the left; and both are smaller than the central column, shown in full. This tends to give the illusion that the spectator point is opposite the centre column of the picture where, psychologically, we expect to find the greatest width. The base of this central column appears distorted, if viewed by itself; but the eye is drawn upwards to the diamond-shaped escutcheon, the area of greatest tonal contrast. Because this escutcheon is drawn as a true shape a casual observer is deceived into assuming that the rest of the picture is also undistorted. When the picture is viewed from the spectator point, however, the columns appear undistorted but the escutcheon is strongly foreshortened.

Van Gogh's *Vincent's Room*[5] (fig. 88) shows an entirely different approach to the problems involved in using a wide angle of view. Drawing the interior of a small room in perspective is always difficult if the artist, and hence the spectator point, is to be

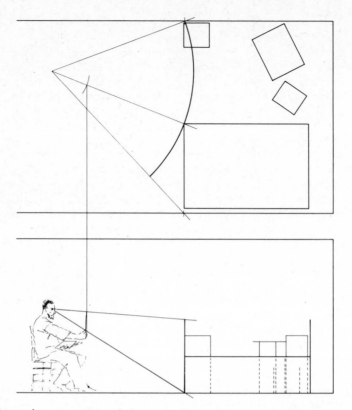

89. A plan and cross-section of the scene depicted in Van Gogh's *Vincent's Room*, adapted from Heelan (1972), showing in addition a curved picture plane and the artist taking measurements of the scene using a brush held at arm's length.

within the room. If a small angle of view is used, only a very small portion of the room can be included in the picture, while if a large angle of view is used distortions appear at the edges of the picture. One solution is to take the spectator point outside the room, as Bonnard did in his *Nude in a Bathtub* (fig. 29). In spite of the apparent intimacy of the picture, the spectator is, notionally, at an infinite distance away, looking down at an angle through the ceiling of the bathroom. Pictures of this kind (that is, pictures in systems approximating to one of the parallel projections) must however be *constructed*, since they cannot be drawn from life without removing the ceiling or one of the end walls. At the other extreme, all the evidence suggests that Van Gogh painted *Vincent's Room* from life from a position well within the room; while the very noticeable curvature of the floor and the end of the bed suggests that the picture can best be described in terms of synthetic rather than artificial perspective. Fig. 89 shows a plan and cross-section of Vincent's bedroom adapted from Heelan (1972) in which the dimensions of the drawings have been inferred from the known or estimated

dimensions of the room and the furniture in it. Fig. 89 shows as well a position for the spectator point, also suggested by Heelan[6].

In the original picture, straight lines in the picture are used to represent vertical edges in the scene. This suggests the use of a cylindrical picture plane, with the centre of curvature centred on the spectator point. Using Heelan's dimensions as a starting point, the positions of all the points in the room may be mapped onto this cylindrical picture plane; and the picture plane may then be rolled back on to a plain surface, to give the result shown in fig 90. On the whole, the agreement between this reconstruction and the original picture is remarkably good. The most noticeable differences are that the end of the bed appears wider in the reconstruction than it does in the original; and the original painting shows more of the top of the table and the seat of the chair at the far end of the room. Changing the width of the bed in the reconstruction could be approached in three ways: either the width of the bed in Heelan's suggested plan could be reduced; or the radius of curvature of the picture plane could be reduced; or these two approaches could be combined. By progressive alteration of these factors a reconstruction which was rather more faithful to the original could probably be produced; but in fact there is not much point in continuing the analysis in this way because it is obvious that Van Gogh did not produce *Vincent's Room* by using some strict optical or geometric method. If the edges of the room which are hidden behind the bed are completed, for example, it will be seen that the far end of the bed projects into the right-hand wall, which is impossible. The exaggeration of the shapes of the table top and the seat of the chair towards their true shapes are, on the other hand, almost certainly due to the effects of shape constancy (that is, the universal tendency to see, and draw, objects as true shapes rather than as projected shapes.

90. The projection in synthetic perspective which would result from the arrangement shown in fig. 89.

This leads on to the question of how *Vincent's Room* was actually painted. Heelan claims that Van Gogh perceived the world, at times, in a special non-Euclidean way, so that he actually experienced the world as curved according to the laws of 'hypobolic geometry'. There is, however, no need for such a complex explanation. One very common way of drawing is to judge the apparent sizes and orientations of the edges of objects by measuring of their lengths and angles on a pencil or paintbrush held at arm's length[7]. These lengths and angles are then transferred on to the surface of the paper or canvas[8]. Obviously there are inherent inaccuracies in this method; but even in theory, a picture approximating to normal artificial perspective will only be produced if the angle of view is fairly small, so that the surface described by the pencil or paintbrush, as the artist swings his arm round to judge each part of the scene in turn, approximates to a flat plane. If the angle of view is large, then this surface will approximate to a section of a sphere; or, if the width of the picture is greater than its height, to a rough cylinder. Thus, pictures produced in this traditional way, by measuring along the paintbrush, will approximate to synthetic perspectives if the angle of view is large. In *Vincent's Room* the angle of view is about 65°, quite sufficient to account for the curvature in the picture.

Fig. 89 shows the artist holding up a paintbrush at arm's length, in order to judge the length of the near front edge of the bed. Heelan does not give a scale for his drawing; but assuming the height of the seat of each chair to be 18in. [45cm.] a scale for the drawing can be calculated. If the horizontal distance from the brush to the eye is taken as 27in. [68cm.], the apparent length of the near edge of the bed, measured at the brush, is 13.5in. [34.5cm.]. This may be compared with the length shown in the original picture, which is 15.5in. [39.5cm.]. Given the number of assumptions involved (especially the sizes of the furniture and the position of the artist) this seems a sufficiently close agreement to support the view that Van Gogh used direct measurements along the brush in order to paint his picture. Van Gogh's originality as an artist thus lay not in some special peculiarity of his visual system, but in his determination to record the scene in the light of his own individual judgments about the appearances of objects, as his attention, and hence his local line of sight, was directed towards each part of the scene in turn. How far the *expressive* effect obtained by this use of synthetic perspective was deliberate remains a matter of speculation.

Van Gogh is not, however, the only artist to have used synthetic perspective. White (1957) discusses two other examples: the paintings of Jean Fouquet and the manuscript painting *Isabel of Bavaria and Christine de Pisan* (fig. 91). Fouquet consistently used curved lines in his paintings to represent straight edges; perhaps he was influenced by the theoretical ideas of Leonardo da Vinci, of whom he was a near contemporary. The *Isabel of Bavaria* painting does not contain curved lines; but the end of the bed to the left and the end of the couch to the right are shown foreshortened, as they would be in relation to the spectator's local line of sight, directed towards each object in turn; as White says:

> The artist recognizes that, as head and eye are turned in order to survey each individual object, each in turn recedes obliquely from the onlooker – as in nature, so in art.
>
> White (1957), p. 224

If the edges of the ends of the bed were to be continued, they would have to meet in a curve; but this potential embarrassment is avoided by the use of a group of figures

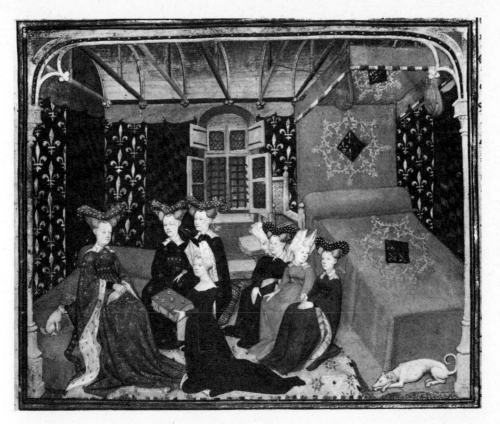

91. *Isabel of Bavaria and Christine de Pisan.* MS Harley 4431, Folio 3, British Museum, London.

in the centre. Apart from this group of figures, the composition of the picture, with the furniture to right and left and the window in the end wall, and the use of an approximation to synthetic perspective, seems remarkably similar to *Vincent's Room.*

Anamorphic projection

Anamorphic pictures, objects or tableaux, are those where the image is seen as correct from one specific viewing position only, and with one eye. One of the best known examples of this type of image is to be seen in Holbein's *Ambassadors.* Fig. 92 shows the picture seen from the front and fig. 93 reveals that the enigmatical form between the two men is a skull when seen from a correct viewing position, that is, from the bottom right-hand side of the picture, outside the picture plane, and a few inches away from the surface of the picture. This type of image is an extreme example of the use of a wide angle of view.

Using a chair and a transparent picture plane, fig. 94 demonstrates how this type

92. Hans Holbein the Younger (1497/8-1543): *The Ambassadors*. Oil on canvas, 81.5 × 82.5in. [207 × 209cm.]. National Gallery, London.

of image may be obtained by primary geometry. The chair is viewed here through the glass at an oblique angle, and an outline of the chair is drawn onto the glass. Fig. 95 shows the same drawings viewed incorrectly, that is, seen from the front with the camera parallel to the picture plane.

Anamorphic pictures may also be obtained by projection from plans and elevations.

93. (above) The skull in *The Ambassadors* seen from a correct viewing position.

94. (below, left) Photograph of a chair seen through glass from an oblique angle. The outline of the chair is drawn on to the glass.

95. (below, right) Photograph of fig. 94, now viewed parallel to the plane of the glass, showing how an anamorphic image was formed.

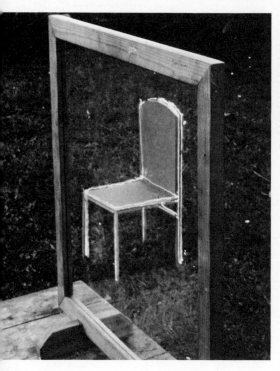

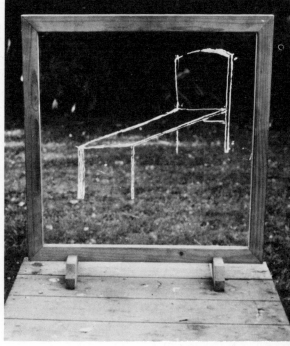

Anamorphic objects and tableaux (Ames' demonstrations)

The purpose of Ames' studies in perception[9] was to demonstrate and single out some of the factors that contribute to the spectator's awareness of the third dimension. In the series of experiments called 'the distorted room demonstrations' he dealt with the factors of linear perspective and scale. The illusion is based on the principle that a particular retinal pattern may be provided by a variety of external configurations. Ames' rooms appear, when viewed from the correct point, to be normal regular rooms, but normal objects or persons placed within these rooms appear distorted and either much too large or much too small according to the position they occupy. The structure of the particular room illustrated in fig. 96 is as follows. The orthogonals or lines and planes at right angles to the picture plane (film plane) remain true and undistorted. The planes that *appear* in the picture to be parallel to the picture plane are set in real space at oblique angles and converge to a single vanishing point. This vanishing point is on the same plane as the film, or the spectator's eyes, but near to the spectator in order to achieve the desired distortion. (See fig. 97, plan; and fig. 98, elevation). Clearly the closer the false vanishing point is to the spectator, the more dramatic the change of scale will appear to be.

96. Photograph of an Ames room, viewed from the correct position.

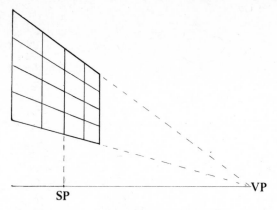

SP →VP

97. (above) Plan of an Ames room. 98. (below) Elevation of an Ames room.

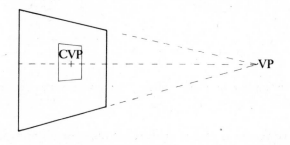

CVP →VP

Anamorphic stage design, sculpture, fresco painting[10], and architecture

Palladio designed and built the Olympic Theatre in Vicenza; work on the building was finished in 1580. The scenery was designed and built by Scamozzi between 1584 and 1585, and it is used for theatrical performances to this day.

In front of the proscenium the audience can perceive a normal horizontal stage, and behind the opening it appears that there are roadways and buildings. In reality the roadway behind the central archway slopes upwards from the proscenium and becomes very narrow at the top; the buildings also diminish in size, in perfect accord with the road. The sets are made of stuccoed wood. The illusion of deep space is a piece of theatrical magic, and was achieved by using accelerated perspective.

The diagram (fig. 99) shows how this type of illusion works. The degree of acceleration depends on the following factors: (i) the height of the stage above the level of the auditorium, and hence the height of the notional central vanishing point; (ii) the size and angle of slope of the stage: 1 in 10 is considered acceptable by actors; and (iii) the location of the distance point, which is determined by the viewing position in the auditorium, as well as the real space of the stage.

Guilio Troili (1613-1685) and Andrea Pozzo (1642-1709)[11] wrote practical handbooks about perspective and included sections on accelerated perspective. There is little doubt that these works were to influence the designs of the Italian Baroque stages that were to follow.

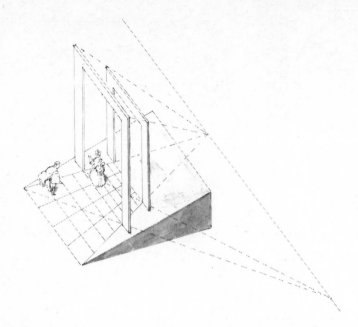

99. Diagram showing how an illusion of deep space (accelerated perspective) may be achieved.

Decelerating perspective is used to achieve the opposite illusion: distant objects or figures are enlarged so that they appear nearer than they are. In the fresco painting of the Last Judgment in the Sistine Chapel in Rome, by Michelangelo, there are three distinct horizontal zones which become progressively larger towards the ceiling. The correct viewing position is in the axis in front of the steps of the podium: in this place each zone subtends the same angle of vision, making the figures appear to be the same size.

The architect Borromini (1599-1667) designed the arcade in the Palazzo Spada in Rome. This solid perspective arcade encloses a space that in reality resembles a giant wedge, like the street scenes in the theatre in Vicenza. The large end is the entrance, the spaces between the columns on either side decrease as they recede, and the width and height of the arcade get smaller towards the end. Thus at the entrance the viewer experiences an illusion of an arcade longer than it is in reality (this is accelerated perspective) and looking back towards the entrance from the other end the perspective is decelerated, the arcade appearing shorter than in reality.

Real depth is reduced to a minimum of a few inches in relief sculpture, and even less on coins and medallions. Accelerated perspective was used to create an illusion of depth on four sculptures decorating the ground floor facade of the Scuola di San Marco (now the Civic Hospital) in Venice (figs 100 and 101). They are believed to be by Tullio Lombardo[12], and were made between 1487 and 1496 when the Lombardo family were designing and working in the building.

The final stage in the reduction of real depth is in painting, where the Z coordinates are reduced to zero and illusionistic devices are the only means of representing depth.

100. and 101. Relief sculptures on the façade of the Scuola di San Marco.

9. Sciagraphy,
or the projection of shadows

Most pictures in colour are easier to read than black and white pictures; by the addition of the element of colour, the spectator is given more texture and depth cues. For example, the popular use of colour photography and the latitude of colour film has enabled the amateur photographer to take pictures that are more readable than black and white pictures; to use black and white only, requires a degree of abstraction which most amateurs find difficult to achieve. Similarly, drawings in black and white using formal modelling and shadows are easier to read than pure line drawings. The use of tonal modelling and shadows can not only give a greater illusion of reality than pure line drawing, but also an expressive use of lighting can dramatize a composition. A portrait which is 'back lit' like a silhouette will express aspects of a person that are quite different from the same portrait 'front lit'.

There are two kinds of shadows: those projected from the sun which is at a great distance, and those from a source of light which is comparatively near, an electric light bulb for instance. When shadows are cast by the sun the rays of light, for pictorial purposes, may be considered parallel to each other. When shadows are cast from an electric light bulb the rays of light diverge from the source of light.

Shadows cast by the sun's rays

The sun may occupy, with regard to perspective constructions, one of the following positions:

(i) in the plane of the picture, where shadows of an object will be parallel to the picture plane (figs 102 and 103),
(ii) behind the picture, where the shadows of an object will be cast towards the spectator (figs 104 and 105),
(iii) in front of the picture where the shadows of an object will be cast away from the spectator (figs 106 and 107).

To construct a perspective projection of shadows it is necessary to know the relative position of the following: the spectator, the picture plane, the object, the source of light, and the surface which receives the shadow. The surface which receives the shadow may be called the 'plane of projection'.

The vanishing point of the sun's rays

When the sun is behind the picture, the rays of light (because they are considered to be parallel) cast shadows converging to a vanishing point. As we know that a vanishing point represents, on the picture plane, a point at an infinite distance, it follows that

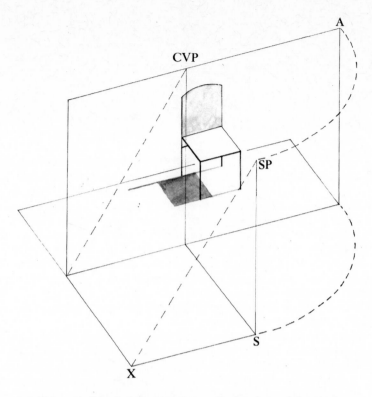

102. Trimetric drawing showing the sun in the plane of the picture.

103. Perspective drawing showing the sun in the plane of the picture.

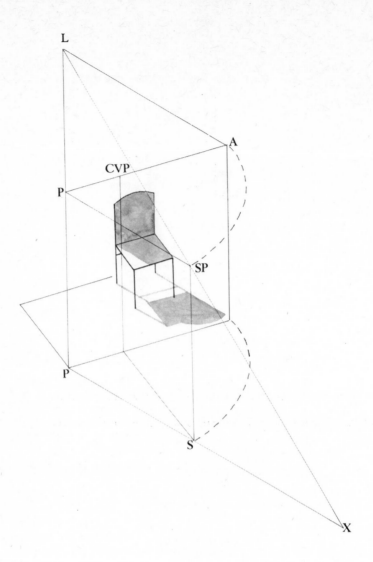

104. Trimetric drawing showing the sun behind the picture (i.e. in front of the spectator). Where SP is the spectator point (spectator's eye), and s the spectator's position on the plane of projection (point on the plane vertically below the spectator's eye), the sun's rays from L will project a shadow on the plane of projection terminating at x. Now sx will indicate the direction of the sun and SPx the angle of the sun; it follows that a line drawn from x through s to the plane of the picture at p will indicate the direction of the sun. A vertical line from p passing through the horizon at P (seat of the light source) will meet L (the sun). To establish the angle of the sun on the picture plane, it is necessary to fold back SP about the axis Pp on to the picture plane: this point is called A. The angle PAL is now the angle of the sun on the picture plane.

105. Perspective drawing showing the sun behind the picture.

in this case, the vanishing point in the picture represents the position of the sun's centre. We may call this the vanishing point of the sun's rays (fig. 104).

When the sun is behind the spectator, rays of light, being considered parallel, will again project shadows of objects that converge to a vanishing point; the position of this point is determined by the intersection with the picture plane of rays of light from the sun passing through the spectator point (fig. 106).

When the sun's rays are parallel to the picture plane, the shadows can simply be drawn geometrically parallel to each other (fig. 102).

The seat of the light source

A line drawn from the centre of the light source, in this case the sun, at right angles to the plane of projection will meet it at a point which we may call the seat of the light source. In figs 102-7 the ground plane is in the plane of projection, L is the vanishing

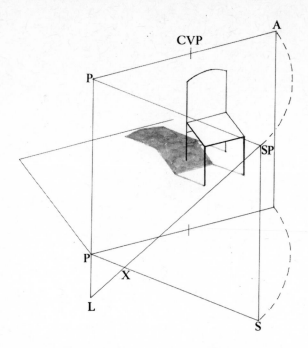

106. Trimetric drawing showing the sun in front of the picture (i.e. behind the spectator). The construction here is similar to fig. 104 except that because the sun is behind the spectator, the vanishing point of the sun's rays L must be located below the plane of projection. But here again the angle PAL is the angle of the sun on the picture plane and P the seat of the light source.

107. Perspective drawing showing the sun in front of the picture.

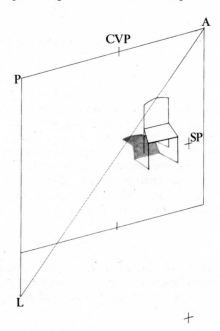

108. Trimetric drawing showing an artificial light source at L and the seat of the light source at P on the plane of projection.

109. Perspective drawing showing an artificial light source.

point of the sun's rays. A vertical line drawn from L to meet the horizon at P, establishes P as the seat of the light source.

As a vanishing point represents a point at infinite distance and the horizon H represents the apparent termination of the ground plane at infinity, we may draw a vertical line from L to meet the horizon at P. Now P is established as the seat of the light source, and determines the direction of the light and subsequent direction of shadows, whereas the position of L determines the angle of the light and subsequent length of shadows.

Figs. 108 and 109 (in trimetric projection) attempt to show how shadows may be constructed where a light source is known to be in a specific position. Once, however, the principles are understood it is in practice unnecessary for the draughtsman to go through such a lengthy process. The position of the light source and the seat of the light source can be established on the picture place and the shadows put in, in the most appropriate and expressive plane in the composition.

Conventional lighting in architectural drawings

It was once common practice for architectural draughtsmen to use conventional fixed lighting coming from one direction only. This had the advantage of enabling the viewer to compare different forms more easily, and, more important, to know from the dimension of the shadows the amount of projection of one surface in front of another. These drawings thus not only gave an illusion of three dimensional form, but were also able to express measurements in the third dimension on the elevation of buildings. The illuminating parallel rays used were 45° in plan and 45° in elevation: (fig. 110) that is, as if they ran in the direction of one of the diagonals of a cube, and so made an angle of 35.26° with the ground plane (see *isometric projection*).

Fig. 110 shows a typical example of the use of conventional lighting.

The projection of inclined planes

It has been seen that in the projection of a shadow it is necessary to know the angle and the direction of the light source; similarly in the projection of an inclined plane it is necessary to know both the angle and direction of that plane, i.e. the tilt and twist. When a plane is inclined away from the spectator there is a vanishing point of the plane above the spectator's eye level; when a plane is inclined towards the spectator there is a vanishing point of the plane below the spectator's eye level. The projection of shadows may therefore be thought of as the projection of inclined planes, since in both cases vanishing points are used above and below the eye level, depending on the direction and angle of the light, or the direction of the plane.

110. An architectural drawing showing the use of formal shadow projection. James Paine (c. 1716-89): *Wardour Castle, Wiltshire.* Pen-and-ink and watercolour. Victoria and Albert Museum, London.

10. *Mixed systems*

Sometimes two or more drawing systems are used together within a single picture. This may occur as the result of the influence of one culture on another, or during a period of transition. Alternatively, the artist may use mixtures of systems deliberately, either to obtain some expressive effect, or in an attempt to come closer to the realities of the perceptual process, or to comment on, or ask questions about, the nature of pictorial structures.

Oblique projection/perspective

The frescoes in the upper church of San Francesco at Assisi which depict the *Legend of St Francis* have traditionally been attributed to Giotto, mainly on the authority of the sixteenth-century biographer, Giorgio Vasari. More recently, this traditional assignment of the frescoes to Giotto has been challenged; and it has recently been said that 'the problem of the attribution of the frescoes is now one of the most animated in the history of Italian art' (Cole, 1976, p. 148). Many of these frescoes contain mixtures of systems, or mixtures of implied directions of view, or both. For example, in the *Vision of the Thrones* (fig. 111), the thrones above are in oblique projection, with the orthogonals strictly parallel; while the altar and its platform and canopy below are in an irregular version of perspective, with the orthogonals converging in a horizontal plane but diverging in a vertical plane. The subject matter of this picture is a 'vision'; and White has pointed out that the change in the implied direction of view from top to bottom 'is accompanied by a change from one reality to another, from a material to a visionary world' (White, 1957, p. 33).

The idea that the artist may have chosen different systems or different implied directions of view to express different kinds of reality is a most attractive one; and certainly to the spectator the use of two different and spatially incompatible systems within a single picture does give a strong suggestion of the supernatural. How deliberate this choice was is less certain.

Almost all the other frescoes in the upper church at Assisi contain mixtures of systems or mixtures of implied directions of view, or both; and not all of them deal with visions. On the other hand, virtually all the frescoes known to be by Giotto (for example, those in the Arena chapel and at Santa Croce) are based on single spatially coherent versions of perspective. This seems to make it less likely that Giotto was responsible for the frescoes at Assisi; if he did paint them, it must have been at some early period when he was still struggling with the transition from oblique projection to perspective. On balance, it seems most likely that the mixture of systems in the 'vision' frescoes at Assisi, which to us looks like deliberate choice, may have been a happy accident; whether or not Giotto was aware of the opportunities for expressive effect which this mixture of systems can offer, he does not seem to have exploited it in his later work. Similarly, pictures by children often seem to us to be extraordinarily expressive because they contain mixtures of systems; but this mixture of systems may be regarded as a defect by children, or simply go unremarked. In contrast, artists in

111. The Master of the St Francis Legend: *Vision of the Thrones*, c. 1297-1300.

our own century, confident of perspective but satiated with it, have been well aware of the expressive effects to be obtained by the use of mixtures of systems.

Surrealism

The classical definition of surrealism is in terms of incongruous subject matter: an encounter between an umbrella and a sewing machine on an operating table. Just as characteristic of surrealist painting, however, is the use of incongruous mixtures of drawing systems. De Chirico, for example, often used a mixture of perspective and oblique projection, or mixtures of perspective which do not quite key together (fig. 112). Here, unlike the 'vision' frescoes at Assisi, the effect is not to suggest two different worlds – heaven and earth – which are ultimately in harmony, but an all too earthly society at odds with itself. Within the context of these pictures, these incongruous mixtures of systems are not just 'mistakes', but the means by which the painter achieves a particular expressive effect.

Similarly J. P. Thorne has suggested that writers often use difficult or even ungrammatical structures for particular ends: what the writer is doing, in effect, 'is to create a new language (or dialect) and ... the task that faces the reader is in some ways like that of learning a new language (or dialect)' (Thorne, 1970, p. 94). Thorne points out, for example, that Donne's *A Nocturnall Upon S. Lucies Day* contains the clause '(mee) who am their Epitaph' and the sentences 'I ... am the grave of all' and 'Yea plants, yea stones detest and love'. These are deviant expressions in normal English, but within the context of the poem they are regularities which serve to express a sense of chaos, and the breakdown of the natural order (p.193).

112. Giorgio de Chirico: *Mystery and Melancholy of a Street*, 1914. 34.8 × 28.4in. [87 × 71cm.]. Stanley R. Resor, New Canaan, Connecticut, U.S.A.

Cubism

We have already seen how artists such as David and Ingres, working in the Neo-Classical manner, tended to move the spectator further away from the picture plane in an imitation of Greek vase paintings, so that paintings began to approximate to orthographic projections. In addition, scientists in the nineteenth century began to realize that vision is not just the reception of sensations on the retina: these sensations are analysed by the brain to provide us with descriptions of the world which are independent of a particular direction of view or a particular moment in time. To begin with, the diminution of the image of a distant object available at the retina is corrected by the perceptual system: distant objects appear larger than the projective geometry of physical optics would register. Secondly, we do not view the world from a fixed viewpoint, nor is our gaze fixed in one direction. Objects move; we move around the world; and we scan each object in the world in turn. In Marr's terminology, the perceptual system uses the constantly changing *viewer-centred* descriptions of the world available at the retina to build internal representations: coherent *object-centred* descriptions of the world which are independent of the incidental movements of the viewer or the object viewed[1]. These object-centred descriptions play a vital biological role in the perceptual process, since descriptions based on a single viewpoint, or a single moment in time, would be almost useless for purposes such as recognition. Every time we encountered an object from a new viewpoint we should have to develop a new description of it; and we should be unable to recognize familiar objects seen from a new direction of view. Thus the truth of Renaissance scientific perspective, which shows us scenes from a single fixed viewpoint and at a single moment in time, began, for the first time, to seem in doubt.

During the second half of the nineteenth century Cézanne began to produce pictures in systems which approximated to the parallel systems rather than to perspective[2], and in 1912 Jacques Rivière wrote:

Perspective is as accidental a thing as lightning. It is the sign, not of a particular moment in time, but of a particular position in space. It indicates not the situation of the objects, but the situation of a spectator.... Hence, in the final analysis, perspective is also the sign of an instant, of the instant when a certain man is at a certain point. What is more, like lighting, it alters them – it dissimulates their true form. In fact, it is a law of optics – that is, a physical law.... Certainly reality shows us those objects mutilated in this way. But in reality, we can change position: a step to the right and a step to the left complete our vision. The knowledge we have of an object is, as I said before, a complex sum of perceptions. The plastic image does not move: it must be complete at first sight; therefore it must renounce perspective.

(Rivière, 1912, pp. 384-406)

The Cubists, particularly Picasso, Braque and Gris, carried the renunciation of perspective a stage further than Cézanne. Gris said, 'Cézanne turns a bottle into a cylinder, but I begin with a cylinder and create an individual of a special type: I made a bottle – a particular bottle – out of a cylinder'. Whereas Cézanne based his paintings on direct observations, Gris said, 'The mathematics of picture-making lead me to the physics of representation'[3]. Whereas Cézanne's paintings are still quite 'realistic' in

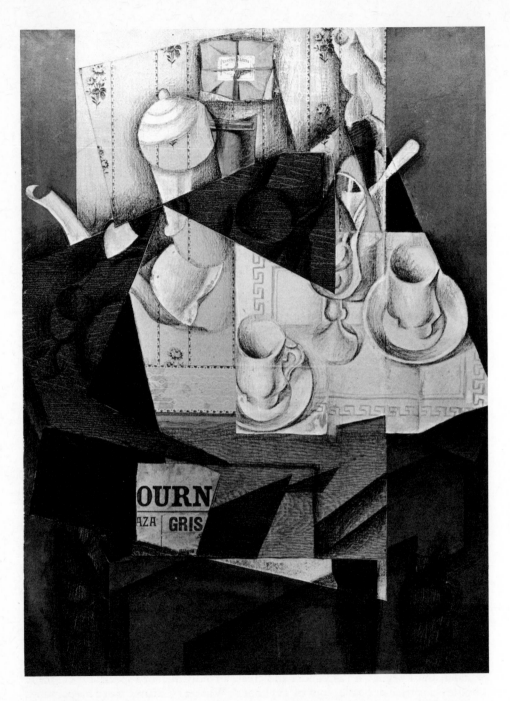

113. Juan Gris: *Breakfast*, 1914. Collage, crayon and oil on canvas. 38.9 × 23.9in. [97.2 × 59.7cm.]. Museum of Modern Art (Lille P. Bliss Bequest), New York.

appearance, Gris' *Breakfast* (fig. 113) seems at first sight to be nothing but a jumble of disconnected fragments. In fact, the picture is very carefully and delicately constructed.

A tracing of the table alone (fig. 114) shows that it is drawn in axonometric projection, a version of vertical oblique projection. The cups, the glass, and various other objects on the table are also in vertical oblique projection. So far, the picture is a reasonably straightforward representation in one of the parallel systems. However, the cubists were anxious that their pictures should stand as objects in themselves, rather than simply being windows into space; and the rest of the picture is made up of a series of devices which invert the normal rules of perspective, destroying the illusion of the real world and emphasizing the picture surface.

First, the rectangular forms of which the picture is composed fan out from the lower half of the picture like a hand of cards, counterfeiting the effect of inverted perspective and disguising the underlying parallel systems (fig. 115). Secondly, the normal rules for the representation of occlusion are inverted or ignored: parts of the scene which would be hidden are included in the painting, and parts which would be visible are left out. Thirdly, Gris makes considerable use of what painters call 'false attachment'

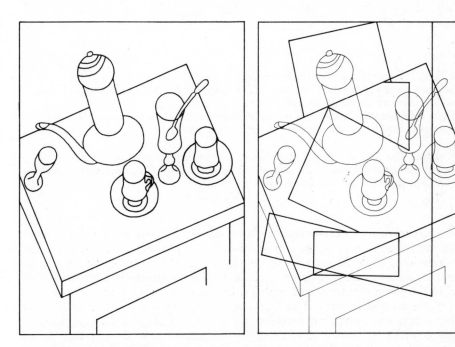

114. (left) The table is in axonometric projection (a version of vertical oblique projection, Chapter 2). The cups are in vertical oblique projection (see fig. 30) and so are various other objects on the table.

115. (right) The rectangular forms fan out from the lower half of the picture like a hand of cards, counterfeiting the effect of inverted perspective and disguising the underlying parallel systems.

116. (left) The normal rules for the representation of occlusion are inverted or ignored; parts of the scene which would be hidden are included in the painting (denoted by zigzag lines) and parts which would be visible are left out (dotted lines).

There are numerous instances of false attachment, both within the picture (asterisks), and between the picture and its frame (double asterisks).

117. (right) The normal rules of atmospheric perspective are inverted by placing the warmest and most fully saturated area of colour at the top, in the background of the picture. The painter signs his name *en collage*.

and what Guzman[4] in an early paper on scene analysis, called 'nasty coincidences'. For example, the top edge of the cup in the centre of the picture is falsely attached to the tablecloth, while the top edge of the cup on the right is falsely attached to the edge of the table. In addition, however, Gris also falsely attached objects within the picture to the picture frame: for example the corner of the table at the right, and the corner of the rectangular area of wallpaper at the top (fig. 116). This destroys, or at least questions, the distinction between the real world and the depicted world; a distinction which is further questioned by the use of real objects, such as the wood-grain paper, the wallpaper, and the newspaper *en collage*. Fourthly, normal atmospheric perspective is reversed. Most of the picture is in dull brown, greys and blues (all recessive colours); but the parcel and the coffee pot lid are in red, swinging the top of the picture (where one would expect to find the greatest depth) toward the spectator. Finally, by introducing part of a newspaper, Gris raises the question of an alternative, non-visual symbol system (verbal language); and then uses the newspaper, very wittily, to sign his name: 'Ourn' (Juan) 'Gris' (fig. 117).

Metalanguage

The primary purpose of painting, like that of verbal language, is to give an account of the real world; when a language or symbol is used for this purpose it is known as an 'object language'. However, a language can also be used to comment on other languages, or on the nature of language: a language used for this purpose is known as a 'metalanguage'. A metalanguage may be in the same language as the object language, or in a different language. Thus, in *The grass is green*, and *Das grass ist grün*, English and German are used as object languages: the sentences tell us something about the real world. However, in both *'The grass is green' is a grammatical sentence in English*, and *'Das grass ist grün' is a grammatical sentence in German*, English is used as a metalanguage, and tells us something about the sentences. Our knowledge that there are many languages, and the necessity of translating from one language to another, raises questions about the nature of language. Why do different peoples have different languages? Is it ever possible to translate fully from one language to another[5]? The more languages differ, the more acute these problems become. The discovery of Sanskrit, and the American Indian languages, led first to the comparative study of languages, and then to linguistics, the study of language for its own sake.

Similarly, the discovery of new geometries (such as Riemannian geometry) in the nineteenth century also led to awkward questions. Hitherto, it had been thought that Euclidian geometry was self-evidently true of the real world; but the discovery of a number of rival candidates, all apparently equally self-consistent, raised the question of which of these geometries was true – if any. This led to the study of formal structures within mathematics, and then to the use of metamathematics to describe these structures[6].

In the same way, the increasing accessibility (through mechanical reproduction) of paintings based on very different drawing systems has led to a situation in which the structures of paintings from different periods and cultures may be compared. Paintings in different drawing systems are compared in this book; but the language we have used to compare them is English. Increasingly, the painters of this century have been concerned with investigating, and commenting on, the nature of painting; but being painters, they have for the most part used the language of painting itself for these comments and explorations. In other words, painters have begun to use painting as a metalanguage. We can see this process developing from at least Cézanne onwards. First, deliberate alternatives to Renaissance linear perspective were explored. Then, with the Cubists, the normal rules were inverted, in order to flatten the picture surface. From this point on, it was only a small step before painters began to explore pictorial structures for their own sake.

One way of exploring pictorial structures has been through *transcription*: a process analogous to translation in verbal language by which a picture in one drawing system is reinterpreted in terms of another system. Fig. 80, showing the scene in Vermeer's *The Music Lesson*, is a very literal transcription; here a picture in perspective has been reworked using axonometric projection. One great advantage of transcription, from the artist's point of view, is that it allows him to explore pictorial structures without worrying too much about the subject matter. Paradoxically, this has led many modern artists to draw their themes from the past. As Steiner puts it, 'The apparent iconoclasts have turned out to be more or less anguished custodians racing through the museum of civilization, seeking order and sanctuary for its treasures before closing time'

118. David Hockney: *Tea Painting in an Illusionistic Style*, 1961. Oil on canvas, 79.2 × 30.4in. [198 × 76cm.]. Collection Bruno Bischofberger, Zurich.

(Steiner, 1975, p. 466). In a way, though, the original subject matter becomes of subsidiary importance because the audience is presumed to be already familiar with it; and the true subject matter becomes the way in which the pictorial structures are handled. Some traditional subjects have proved extremely popular, so that whole series of transcriptions, and transcriptions of transcriptions have been set up. Manet borrowed the composition of a detail from Raphael's *Judgement of Paris* and entitled it *Déjeuner sur l'herbe*[7]: Picasso followed suit, but borrowed Manet's theme and title rather than the composition.

Another recurring theme in modern painting has been the dilemma of the apparently unbridgeable gulf between abstract and figurative art. As David Hockney said:

Immediately after I started at the Royal College, I realized that there were two groups of students there; a traditional group who simply carried on as they had done in Art School, doing still life, life painting and figure compositions; and then what I thought of as the more adventurous lively students, the brightest ones, who were more involved in the art of their time. They were doing big abstract expressionist paintings in hardboard. ... It was in 1963 I painted probably some of the most abstract pictures I'd done, influenced I think, by American abstraction, what they called American cool abstraction. But of course what made it very different was that I was using abstraction as my subject, commenting on it – I felt the *need* to use it as a subject.

(Hockney, 1976, pp. 40, 61-62)

Tea Painting in an Illusionistic Style (fig. 118) was one of Hockney's earliest attempts to come to terms with figurative painting. The canvas is shaped – something usually

associated with abstract painting – but in the form of an oblique projection, so that the blank canvas itself was already illusionistic. Four years later, the references to abstract painting are more overt (fig. 119). The tin cans refer back to Cézanne's cylinders; but only the shadows prevent the images from forming an abstract composition on the picture surface. Moreover, this is not a still life, but a *picture* of a still life. Characteristically, Hockney deals with the dilemma by commenting on it; escaping out of the dilemma of painting as an object language by making a metalinguistic statement about painting.

In written language, quotation marks are used to distinguish metalinguistic statements from sentences in an object language: *Chicago is a populous city* is a statement about Chicago, while *'Chicago' is trisyllabic* is a statement about a word. The first sentence contains the name of the city, while the second sentence contains the name of a word. Neither sentence literally contains the city. Quotation marks are also used for direct quotation: *I asked him where he was going; he replied 'Chicago'.*

119. David Hockney: *Picture of a Still Life*, 1965. Acrylic on canvas, 24.4 × 24.4in. [61 × 61cm.]. Private collection.

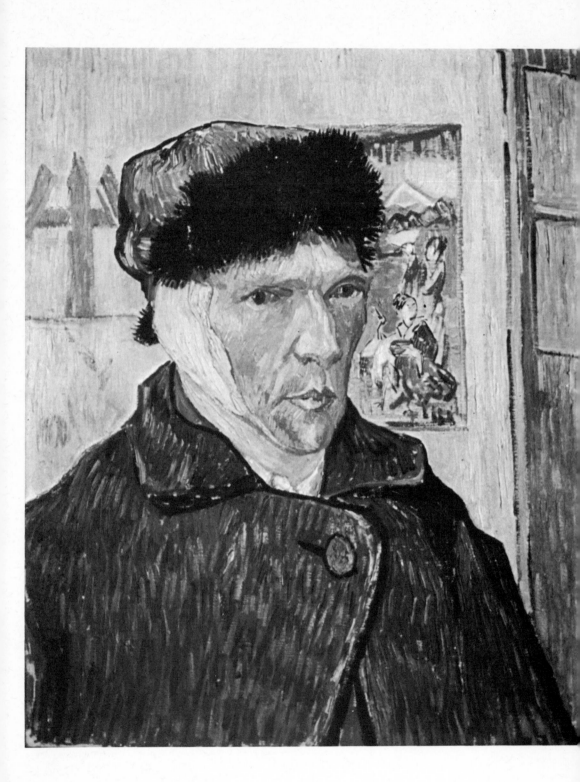

Picture frames act something like quotation marks, clarifying the boundaries between different levels of reality and separating the real world from the symbolic world of the picture surface. Max Clowes pointed out that pictures for analysis by computer ought always to be enclosed by a frame, otherwise the computer would be unable to distinguish between the real world and the marks in the picture (Clowes, 1971). We have already seen how Gris used false attachments between the picture frame and the objects within the picture to question the relationship between pictures and the real world; now in Hockney's *Picture of a Still Life* (fig. 119) the picture frame itself is contained within another picture, adding yet another level of reality.

Many artists have included pictures within their pictures: either in a straightforward way, because pictures themselves appear in the real world, or, less directly, in order to make a comment on the nature of pictures. Van Gogh's *Self Portrait* (fig. 120) includes a Japanese print in the background; but this print is not copied directly but reworked in Van Gogh's own style, so that it becomes a sort of reported speech rather than a direct quotation. Nelson Goodman[8] has argued that *direct* quotation is only possible in pictures where the picture contains the (usually unique) original, so a picture quoting Rembrandt's *Night Watch* directly would have to contain the *Night Watch* itself! Even this kind of pictorial quotation has been attempted: Tom Wesselman's *Still Life* (1963) contains a real television set as well as a *collage* reproduction of the Stuart portrait of George Washington.

In these last pictures, however, we have strayed far away from transformation systems. The questions they ask are about *denotation* systems: what do the marks in the picture stand for? Finally, we are back where we started in the *Introduction*: transformation systems are only half the story.

120. Vincent van Gogh : *Picture of the Artist with Severed Ear.* Oil on canvas, 36.2 × 19.6in. [90.5 × 48.9cm.]. Courtauld Institute, London.

Notes

Introduction

1. The projection systems form a mathematical family, with perspective as the most general case, and orthographic projection as the most special case. Klein (1939) compared the sifting of progessively more general properties from metric geometry with 'the procedure of the chemist, who, by applying ever stronger reagents, isolates increasingly valuable ingredients from his compounds' (p.132).

2. See, for example, White (1957) for the development of drawing systems during the Renaissance.

3. See Note 2, Chapter 2.

4. Marr and Nishihara (1978) define the primitives of a representation as the most elementary units of shape information which the representation makes available. The picture primitives in a line drawing will be line junctions, lines, and regions; and these picture primitives can denote various kinds of scene primitives. If the drawing represents objects having plane faces, the scene primitives will be corners, edges and faces.

5. For an account of the ways in which Klee consistently violated the 'normal' denotation rules, see Willats (1980).

6. A way of categorizing denotation rules, and an account of the way in which they are acquired by children, is proposed in Willats (1981).

Chapter 1

1. Fig. 2 and its caption, and this account of Beck's work, appeared originally in the *Penrose Annual*, 1969, and are reproduced here by kind permission of Ken Garland.

Chapter 2

1. This useful distinction was introduced, and is discussed, in Booker (1963).

2. For accounts of the acquisition of drawing systems by children see Lewis (1963); Willats (1977a); Willats (1977b); Freeman (1980); and Gardner (1980).

3. M.L. Teuber, personal communication. See also her essay in Teuber (1979), pp.261-96, for a brief discussion of nineteenth-century perceptual theories in relation to Cézanne and Cubism.

4. We are grateful to Brian Coe, of the Department of Graphic Information, Royal College of Art, who prepared these drawings and allowed us to reproduce them here.

Chapter 3

1. An object is said to be seen from a general point or direction of view if a small step to one side does not alter the number of corners, edges or faces which the viewer can see (Huffman, 1971). For an example of a picture containing numerous instances of false attachments, see fig. 113, Chapter 10.

2. Perkins (1972) has shown that drawings of a rectangular box, shown in a foreshortened position in oblique projection, are not accepted by adults as possible representaions of a rectangular object.

3. Using Marr's terminology (Marr, 1978) pictures of this kind may be said to be based on transformation from *object-centred* descriptions. Each description is based on a coordinate system defined relative to the principal axes of each object taken in isolation. Descriptions of this kind cannot include information about the orientation of objects relative to the scene, and in pictures based on descriptions of this kind each object is drawn without regard to its position or orientation relative to other objects, or the scene as a whole.

4. For example, Stern (1969), plates 47 and 52.

Chapter 4

1. 'Valuable as they obviously are, traditional grammars are deficient in that they leave unexpressed many of the basic regularities of the language with which they are concerned.... An analysis of the best existing grammars will quickly reveal that this is a defect of principle, not just a matter of empirical detail or logical preciseness. Nevertheless, it seems obvious that the attempt to explore this largely uncharted territory can most profitably begin with a study of the kind of structural information presented by traditional grammars and the kind of linguistic processes that have been exhibited, however informally, in these grammars.'

Chomsky (1965), p.5.

Chapter 5

1. Now often called *linear* perspective to distinguish it from aerial perspective. White (1957) uses the term 'artificial perspective' to distinguish this form of perspective (using a flat picture plane) from synthetic perspective (see Chapter 8). The term 'scientific perspective' is no longer in common use.

2. The section on perspective in the *Oxford Companion to Art* shows that this conception is faulty, and results in curved diagonals joining the corners of the pavement slabs.

3. This is a somewhat simplified and idealized version of the method described by Alberti.

4. This description, and the quotation from Manetti, are based on Hyman (1974).

5. For a recent discussion of the possible meaning of Manetti's description, see Kemp (1978).

6. For example, see Krautheimer and Krautheimer-Hess (1956).

7. For a discussion of the position of the vanishing point, see Edgerton, (1975).

8. Suggested by Lynes (1980).

9. Lynes suggests that the *image* of the end of the stick is aligned with points on the image of the Baptistry, but this seems an unnecessary complication, since it results in a plotted drawing which is upside down.

10. Again, suggested by Lynes (1980).

Chapter 6

1. For general information concerning drawing aids, see Joseph Meder, *Die Handzeichnung, ihre Technik und Entwicklung*, second edition, 1923.

2. For a discussion of the possible use of mirrors by these artists, see Konstam (1980).

Chapter 8

1. J.J. Gibson defined a faithful picture as 'a delineated surface so processed that it yielded a sheaf of light-rays to a given point which is the same as would be the sheaf of rays from the original scene to a given point' (Gibson, 1954, p. 14). Gibson subsequently produced a different definition of pictures based on what he called 'ecological optics' (Gibson, 1971).

2. For examples, see Chapter VIII in Doesschate (1964).

3. The term 'synthetic perspective' is due to White (1957).

4. c.f. Goodman (1978), who argues that there is no such thing as the world 'in itself', but only as many versions of the world as we have symbol systems under which it may be described.

5. Van Gogh made two copies of this painting: one is in the Chicago Art Institute and the other in the Jeu de Paume in Paris. In both of these copies, curved lines in the picture are used to represent straight edges in the scene. In a drawing of the room, in a letter to his brother Theo, the curvature is present but is not so strongly marked; while in a drawing in a letter to Gauguin the room is shown in more or less normal artificial perspective, using straight lines. (Heelan, 1972).

6. Heelan (1972) pp. 4, 81, 482.

7. Paintings or drawings produced in this way are said to be drawn 'sight size'.

8. Alternatively, it may be that Van Gogh, in common with other artists of the period, was so accustomed to drawing 'sight size' that no mechanical aid was necessary.

9. Ames, A., Jun., see Ittelson, W. H., *The Ames Demonstrations in Perception*, Princeton, N.J., Princeton University Press, 1952.

10. For further information see Baltrušaitis, Jurgis, *Anamorphic Art*, Cambridge, Chadwyck-Healey, 1977.

11. Troili, Guilio, *Paradossi per pratticare la prospettiva*, Bologna, 1672. Pozzo, Andrea, *Prospettiva di pittori e architetti*, Rome, 1693-1700.

12. Lorenzetti, Guilio, *Venice and its Lagoon*, Istituto Poligrafico della Liberia dello Stato, Rome, 1961, p. 340.

Chapter 10

1. Marr (1978), and Marr and Nishihara (1978). For a similar argument, in the context of child development, see Harris (1977).

2. See Chapter 2, note 3.

3. Both quotations taken from Kahnweiler (1969) p. 139. We are grateful to Marianne Teuber for drawing our attention to these quotations.

4. Guzman (1968). Work on the analysis of pictures, in the field of Artificial Intelligence, has shown that false attachments in pictures make them more difficult for machines to interpret. For human beings, objects shown from a 'general' direction of view, (Huffman, 1971), so that false attachments are avoided, are more effective as representations; false attachments in pictures tend to flatten the image and destroy the illusion of reality. (See also Chapter 3, note 1.)

5. For a discussion of these and related questions, see Steiner (1975).

6. For an account of the development of metamathematics, see Nagel and Newman (1958).

7. John Rewald put down Manet's 'borrowing' from this source to 'lack of imagination'; see p. 25 and note 17, p.31 in Lipman and Marshall (1978) (a valuable source book for transcriptions, particularly by modern American artists).

8. For a discussion of pictorial quotation, see Goodman (1978), Chapter 3.

References

Booker, P.J., *History of Engineering Drawing*, London, Chatto and Windus, 1963.

Bull, G., (trans.), *Vasari: Lives of the Artists*, Harmondsworth, Penguin Books, 1965.

Carter, B.A.R., 'The use of perspective in Saenredam', *Burlington Magazine*, No. 109, pp. 594-5, 1967.

Chomsky, N., *Aspects of the Theory of Syntax*, Cambridge, Mass., M.I.T. Press, 1965.

Clowes, M.B., 'On seeing things', *Artificial Intelligence*, Vol. 2, No. 1, pp. 79-116, 1971.

Coe, B., *An Atlas for Trimetric Drawing*, London, Royal College of Art, 1981.

Cole, B., *Giotto and Florentine Painting: 1280-1375*, New York, Harper and Row, 1976.

Doesschate, G.T., *Perspective: Fundamentals, Controversials, History*, Nieuwkoop, B. de Graaf, 1964.

Edgerton, S.Y., *The Renaissance Rediscovery of Linear Perspective*, New York, Harper and Row, 1975.

Freeman, N.H., *Strategies of Representation in Young Children*, London, Academic Press, 1980.

Gardner, H., *Artful Scribbles*, New York, Basic Books, 1980.

Gibson, J.J., 'A theory of pictorial perception', *Audio-Visual Communications Review*, Vol. 1, No. 3, 1954.

Gibson, J.J. 'The information available in pictures', *Leonardo*, No. 4, pp. 27-35, 1971.

Goldwater, R. and Treves, M., *Artists on Art*, London, John Murray, 1945.

Goodman, N., *Ways of Worldmaking*, Indianapolis, Hackett, 1978.

Guzman, A., 'Decomposition of a visual scene into three-dimensional bodies', *Proceedings of the Fall Joint Computer Conference*, pp. 291-306, Washington, D.C., Thomson Book Co., 1968.

Harris, P., 'The child's representation of space', in Butterworth, G., (ed.), *The Child's Representation of the World*, New York and London, Plenum Press, 1977.

Heelan, P.A., 'Towards a new analysis of the pictorial space of Vincent Van Gogh', *Art Bulletin*, No. 54, pp. 478-92, 1972.

Hockney, D. *David Hockney by David Hockney*, London, Thames and Hudson, 1976.

Huffman, D.A., 'Impossible objects as nonsense sentences', in Meltzer, B. and Mitchie, D., (eds.), *Machine Intelligence, 6*, Edinburgh, University Press, 1971.

Hyman, I., (ed.), *Brunelleschi in Perspective*, Englewood Cliffs, New Jersey, Prentice Hall, 1974.

Kahnweiler, D-H., *Gris*, London, Thames and Hudson, 1969.

Kemp, M., 'Science, non-science and nonsense: the interpretation of Brunelleschi's perspective', *Art History*, Vol. 1, No. 2, pp. 134-66, 1978.

Kennedy, J., *The Psychology of Picture Perception*, San Francisco, Jossey Bass, 1974.

Klein, F., *Elementary Mathematics from an Advanced Standpoint*, London, Macmillan, 1939.

Konstam, N., 'Vermeer's method of observation', *The Artist*, No. 95, pp. 22-5, 1980.

Krautheimer, R. and Krautheimer-Hess, T., *Lorenzo Ghiberti*, Princeton, N.J., Princeton University Press, 1956.

Lewis, H.P., 'Spatial representation in drawings as a correlate of development and a basis for picture preference', *Journal of Genetic Psychology*, No. 102, pp. 95-105, 1963.

Lipman, J. and Marshall, R., *Art about Art*, New York, Dutton, 1978.

Lynes, J. 'Brunelleschi's perspective reconsidered', *Perception*, No. 9, pp. 87-99, 1980.

Marr, D., 'Analysis of occluding contour', *Proceedings of the Royal Society, London, B*, No. 197, pp. 441-75, 1977.

Marr, D., 'Representing visual information: a computational approach', in Hanson, A.R. and Riseman, E.M., (eds.), *Computer Vision*, New York, Academic Press, 1978.

Marr, D. and Nishihara, H.K., 'Representation and recognition of the spatial organization of three-dimensional shapes', *Proceedings of the Royal Society, London, B*, No. 200, pp. 269-94, 1978.

Martindale, A. and Baccheschi, E., *The Complete Paintings of Giotto*, London, Weidenfeld and Nicolson, 1969.

Nagel, E., and Newman, J.R., *Gödel's Proof*, New York, University Press, 1958.

Perkins, D., 'Visual discrimination between rectangular and nonrectangular parallelopipeds' in *Perception and Psychophysics, 12*, No. 5, pp. 396–400, 1972.

Prager, F.D. and Scaglia, G., *Brunelleschi: Studies of his Technology and Inventions*, Cambridge, Mass., M.I.T. Press, 1970.

Rivière, J., 'Sur les tendances actuelles de la peinture', *Revue d'Europe et d'Amérique*, Vol. 1, pp. 384-406, 1912.

Steiner, G., *After Babel*, London, Oxford University Press, 1975.

Stern, H.P., *Master Prints of Japan*, New York, Harry N. Abrams, 1969.

Teuber, M.L., Exhibition catalogue, *Paul Klee*, ed. A. Zweite., Munich, Lenbach House, 1979.

Thorne, J.P., 'Generative grammar and stylistic analysis', in Lyons, J., (ed.), *New Horizons in Linguistics*, Harmondsworth, Penguin Books, 1970.

White, J., *The Birth and Rebirth of Pictorial Space*, London, Faber and Faber, 1957.

Willats, J., 'How children learn to draw realistic pictures', *Quarterly Journal of Experimental Psychology*, No. 29, pp. 367-82, 1977 (a).

Willats, J., 'How children learn to represent three-dimensional space in drawings', in Butterworth, G., (ed.), *The Child's Representation of the World*, New York and London, Plenum Press, 1977 (b).

Willats, J., 'On the depiction of smooth forms in a group of paintings by Paul Klee', *Leonardo*, Vol. 13, No. 4, pp. 276-82, 1980.

Willats, J., 'What do marks in the picture stand for? The child's acquisition of systems of transformation and denotation', *Review of Research in Visual Arts Education*, No. 13, pp. 18-33, 1981.

Index of technical terms

References to figure numbers are given in italics